THE *Queer* S MOVIE POSTER BOOK

THE QUEER

BY *Jenni Olson*

MOVIE
POSTER BOOK

CHRONICLE BOOKS
SAN FRANCISCO

ACKNOWLEDGMENTS

This book is dedicated to the late gay British documentarian and AIDS activist Stuart Marshall. Stuart suggested the idea for this book to me back in 1991, when we first met at the Amsterdam Gay & Lesbian Film Festival. My first two attempts to find a publisher both failed, and I'm extremely grateful to Chronicle Books and my editor, Alan Rapp, for catching up with Stuart's vision more than a decade later.

Many, many people were generous with their time and materials in bringing this book to fruition. Special thanks to all my poster sources: Sabin Gray at Backlot Books (backlotbooks.com), everyone at Frameline (frameline.org), Susan Stryker and Kim Klausner at the San Francisco GLBT Historical Society (glbthistory.org), Kym at Bijou Video/Hand-in-Hand Films (bijouworld.com), Sande Zeig at Artistic License Films (artlic.com), Jessica Rosner at Kino International (kino.com), Marcus Hu at Strand Releasing (strandreleasing.com), Jennifer Stott and Robin Zlatin at Fine Line Features (flf.com), Marc Mauceri at First Run Features (firstrunfeatures.com), Nancy Gerstman at Zeitgeist Films (zeitgeistfilms.com), Doug Witkins at Picture This (picturethisent.com), Quentin Lee at Margin Films (marginfilms.com), John Vanco at Cowboy Pictures (cowboypictures.com), Heather Rossi at HBO (hbo.com), Channing Lyle Thomson (channingposters.com), Susan Carnival at Mata Films, Alonso Duralde, JEB, Joel Shepard, Wakefield Poole, Jennie Livingston, Lawrence Helman, Travis Pagel, Dolly Hall, Maria Maggenti, Anthology Film Archives, Telling Pictures, Wolfe Video, World of Wonder, Steakhaus Productions, Donald Goldmacher Productions, Filmmuseum Berlin—Stiftung Deutsche Kinemathek, Signifyin' Works, FallsApart Productions, and all the folks on eBay and elsewhere who have sold me such great queer movie memorabilia over the years. I also want to thank all the other studios, distributors, artists, and designers whose images appear here for their magnificent array of talents.

Thanks for additional assistance and advice to Monica Nolan, Michael Ehrenzweig, Raymond Murray, Richard Dyer, Andrea Weiss, Tom Rielly, Judith Halberstam, Louise Rafkin, Lucian James, and Martin Humphries and Ronald Grant at the Cinema Museum, and thanks to that miraculously expansive source of information known as the Internet Movie Database (imdb.com). I'm grateful to Bruce Vilanch for his wonderfully flattering foreword. I'm also extremely grateful to my book designer, Aisha Burnes; poster photographer, Joe MacDonald; copyeditor, Laura Harger; and Brett MacFadden at Chronicle Books. More than anyone else, I want to thank my partner, Julie Dorf, and my daughters, Hazel and Sylvie. I am continually amazed at my good fortune in having such a supportive family.

Last, thanks to the late Vito Russo for his phenomenally powerful, informative, and inspiring book *The Celluloid Closet*; and to my absent yet ever-present friend, the late Mark Finch.

I hope you enjoy all the fabulous materials on view here; most of them are now part of the collection of the GLBT Historical Society in San Francisco. If you have questions or comments, I would love to hear from you. Please visit my Web site, www.queermovieposters.com, to reach me and to find out more about the wonderful world of queer movie posters. The site includes links to sources of queer movie memorabilia, as well as a selection of materials that I was not able to include in this book.

TEXT COPYRIGHT © 2004 by JENNI OLSON.

FOREWORD COPYRIGHT © 2004 by BRUCE VILANCH.

BEFORE NIGHT FALLS copyright © 2000, New Line Productions, Inc. All rights reserved. Poster appears courtesy of New Line Productions, Inc.
HEDWIG AND THE ANGRY INCH copyright © 2001, New Line Productions, Inc. All rights reserved. Poster appears courtesy of New Line Productions, Inc.
TORCH SONG TRILOGY copyright © 1988, New Line Productions, Inc. All rights reserved. Poster appears courtesy of New Line Productions, Inc.
NORMAL poster appears courtesy of HBO.

LIBRARY OF CONGRESS CATALOGING-IN-PUBLICATION DATA AVAILABLE.

ISBN 0-8118-4261-4

MANUFACTURED in HONG KONG.

DESIGNED by AISHA BURNES.

DISTRIBUTED IN CANADA BY
RAINCOAST BOOKS
9050 Shaughnessy Street
Vancouver, British Columbia V6P 6E5

10 9 8 7 6 5 4 3 2 1

CHRONICLE BOOKS LLC
85 Second Street
San Francisco, California 94105
www.chroniclebooks.com

FOREWORD

BY **BRUCE VILANCH**

A few years ago, I was involved with a very serious group devoted to presenting gay plays to gay audiences—and to anybody else who happened to stumble by the theater. As the theater was on Santa Monica Boulevard in West Hollywood, this meant we got a lot of transgendered hookers and people who spoke only Russian, and the occasional Russian-speaking transgendered hooker, but believe me, he/she was really occasional.

The theater did a lot of good work, but we noticed that the only plays that really drew sizable crowds were the ones featuring male nudity. When the balance sheet got to looking so pale that the place was about to go on life support, the artistic director came up with the idea of a musical revue called *Naked Boys Singing!* This was a stroke of marketing genius. For the first time, a gay show was presented to a gay audience with absolutely no tricks—except the ones the audience brought with them. And the lesbian dramas and gay Asian think-plays continued to have a home as a result.

If only Hollywood had discovered this strategy back in the day!

In this book, Jenni Olson shows us scads of the oblique, tortured, and downright misleading posters that studio marketers have created when—

for one reason or another—they couldn't simply advertise their goods straightforwardly. Sometimes they were afraid of alienating straight ticket-buyers. Sometimes the subject matter was just too outré for any but the hippest, or most fetishistic, crowd, and things had to be cloaked in some sort of respectability, kind of like the sequence in *Gypsy* when Mama Rose's teenage blondes are booked into a burlesque house in Wichita just to keep the cops away. And sometimes the marketers just didn't know what they were doing.

In any event, these stabs at seduction are fascinating to study. I love the idea that Tennessee Williams' *Suddenly, Last Summer* (which is all about cannibalism and homosexuality and lobotomies) was promoted with the central image of Elizabeth Taylor in a wet, transparent bathing suit. Or that the director of *The Boys in the Band* felt secure in proclaiming that his movie was not about homosexuality, which I'm sure was followed by a great sigh of relief from the musicians' union local 802. It's interesting to watch the movie ads themselves go from coded to blatant over the years. As the times change, gay themes finally have been allowed their place in the sun and promoted accordingly (*101 Rent Boys* on screen is surely the next best thing to *Naked Boys Singing!* on stage).

Of course, before there were "gay movies," gay people were going to the movies like everybody else. We found films that spoke to us, and the coy marketing of many of those films presaged what was to come. My favorite preliberation movie ad is the one for the Bette Davis camp classic *Beyond the Forest*, which was advertised as being about "Rosa Moline—a twelve o'clock girl... in a nine o'clock town." Any gay person at the time knew exactly what that message meant—it was how we all felt every night, and most days.

Fortunately, times really do change, and we're living in a world where "bar codes" are no longer the things one says or wears in certain saloons. Enjoy the evolution of the message as Jenni Olson has chronicled it. She's got a queer eye for the straight guy's vision of how we've been pitched and sold over the years—from "untalked-about" audience to desirable niche market, we have come a long, long way.

INTRODUCTION

Surveying the expansive history of queer-themed movie posters, we can see certain recurring tropes and strategies that became the standardized conventions of gay movie marketing: the colors lavender and pink; words such as *different* and *strange;* torn images and mirror images meant to suggest internal psychological struggle; two women or two men together, looking like more than friends; a group of brightly clothed people who look exceptionally happy; a handsome, hunky white guy with his shirt off.

These days, gay indie movie posters featuring sexy, near-naked men have become as predictable a trope as the tortured queer perverts of posters in the late '50s and early '60s, the early days of gay film. Of course, both of these figures function as a lowest-common-denominator marketing strategy (they both promise a look at the intimate lives of homosexuals). In the early days, the audience that marketers pitched to was clearly straight, and the portraits that emerged of our lives were less than flattering, to say the least. Although today's buffed torso may be a shallow, below-the-belt sales pitch, one can't help feeling a sense of pride and excitement at these bold, straightforward appeals to the gay male libido. We've come a long way from the first major U.S. release of a gay-themed film. The campaign for 1961's *Victim* refused to even say what the film was about, relying instead on this mysteriously provocative tagline—"A scorching drama of the most un-talked-about subject of our time!"—alongside a grimacing image of Dirk Bogarde as the titular Tortured Pervert.

This weird promotional closet continued to be a distinguishing feature of gay movie marketing even into the '90s, with a film's posters and ads often having a contradictory relationship to the actual movie being promoted. Consider the campaigns for two popular gay releases—from 1988, *Torch Song Trilogy* ("It's not just about some people; it's about everyone"); and from 1991, *Longtime Companion* ("A motion picture for everyone").

To whom are these pitches directed? Does "everyone" mean all the straight people who won't go see it if it's just about "some people"? This extremely common practice—describing a film as having "universal" appeal (as if to say, "Really, it's not a gay film")—is primarily a strategy for crossing over to mainstream audiences. It's all about selling as many

tickets as possible. But there is also a certain strain of homophobia in these word choices, and in this desperate avoidance of the "gay film" label.

Vito Russo's book *The Celluloid Closet* recounts a long history of similar denials by those involved in the production and promotion of "gay, but not gay" Hollywood films. For example, director William Wyler: "*The Children's Hour* is not about lesbianism." Actor Rod Steiger: "*The Sergeant* is not about homosexuality; it's about loneliness." Director William Friedkin: "*The Boys in the Band* is not about homosexuality." Director Friedkin again: "*Cruising* is not about homosexuality." And the list goes on. To play devil's advocate, one can't blame filmmakers for wanting as broad an audience as possible, or for not wanting to have their work pigeonholed as *just* a queer film. But sometimes they protest too much. (*Boys Don't Cry* [1999], *Far from Heaven* [2002], and *The Hours* [2002] are all excellent examples of films that simultaneously deserve and transcend the queer-film label.)

Truth be told, those oblique and euphemistic posters of bygone days are the most enjoyable to look at now. These amusing artifacts of Hollywood's struggle to represent our lives illuminate a very different era in queer history. Witness the poignant beauty of the posters for *The Children's Hour* (1961) and *This Special Friendship* (1964) and the coy contortions of those for *Some of My Best Friends Are...* (1971) and *Sunday, Bloody Sunday* (1971).

Happily, there are also many, many queer films with proudly out promotional campaigns. The posters for *Word Is Out* (1978), *Tongues Untied* (1991), *The Incredibly True Adventure of Two Girls in Love* (1995), and *Hedwig and the Angry Inch* (2001) are just a few of the historic high points of bold queer film marketing.

With one or two exceptions, the marketing campaigns that follow are pitching 100 percent certified queer movies (whether you can tell that from the posters or not).

A BRIEF MOVIE POSTER PRIMER

A word about the terminology of movie marketing materials that is utilized throughout the book: Standard-size (approximately twenty-seven-by-forty-one-inch) movie posters are known as one-sheets; the next most common sizes are the twenty-eight-by-twenty-two-inch half-sheet and the fourteen-by-thirty-six-inch insert. We'll also see a few British quads (forty by thirty inches), several nonstandard American posters, and a handful of sizes from other countries. In addition, I've included several examples of advertisements and materials taken from the original press books (also known as campaign manuals). Press books were circulated to theater managers and contained sample ads (in different sizes, shapes, styles, and layouts), promotional ideas, sample press releases, and examples of the posters and other materials that could be ordered to help promote a given film. With some films, we'll see two or more different styles of posters (called styles A, B, C, etc.). Often the styles were designed to appeal to different markets, though in some cases the design was changed during a film's run to emphasize a different marketing angle or to tout new awards or reviews.

I've organized all the images primarily by decade, with some additional sidebar sections that explore particular areas such as transgender images, queers of color, and so forth. Within each decade, I've grouped gay posters together and lesbian posters together to more easily explore similarities between marketing strategies targeting these distinct groups. This book is focused primarily on the marketing of gay film in the United States, but in some cases I have included non-U.S. designs, especially in cases where they are more interesting than the U.S. versions.

While this book is not a comprehensive overview of gay, lesbian, bisexual, and transgender (GLBT) movie posters, I think you'll find it to be a very thorough survey. Forgive me if one of your favorites is missing. After scouring through hundreds of queer movie posters, I've attempted to showcase the best specimens of graphic design and to give a representative sampling of posters from a variety of eras and genres. I assure you, these are the cream of the crop.

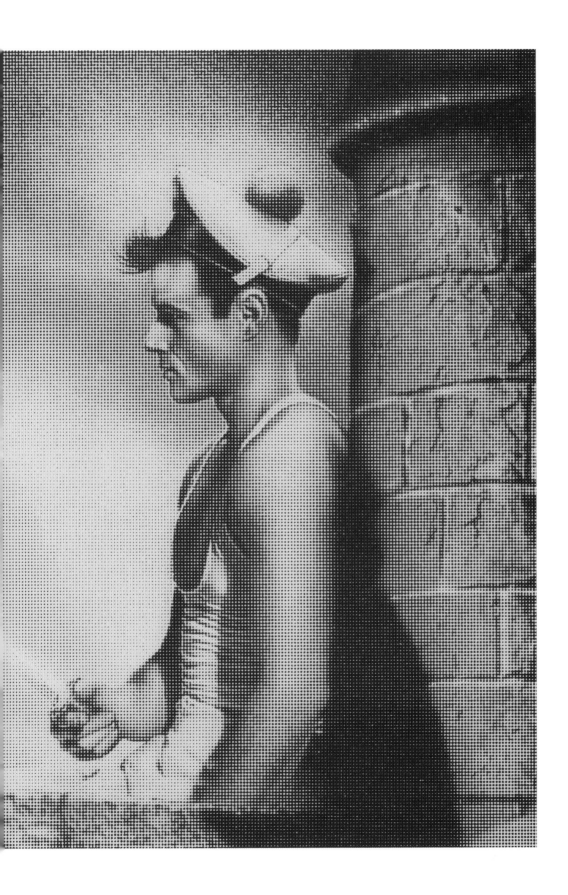

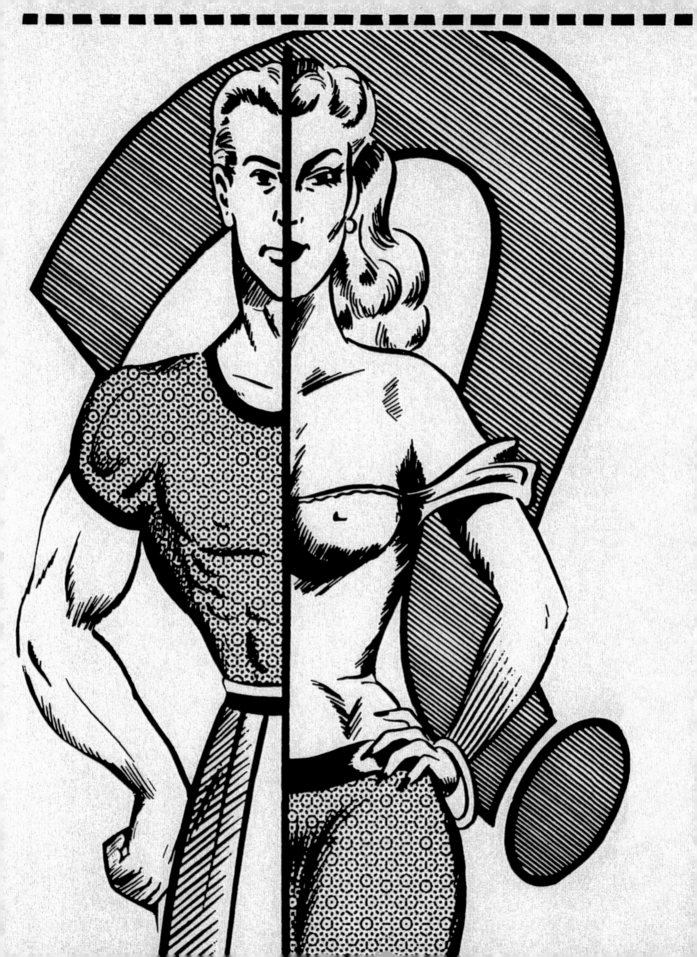

THE EARLY DAYS

CHAPTER I

In the first fifty years of world cinema, only a small handful of films took homosexuality as a primary theme. Yet scores of subtly (and not so subtly) coded queer characters populated the casts of Hollywood's Golden Age.

Hollywood's self-imposed Production Code severely limited the content of American films made from 1934 to the early '60s. Though the Code was adopted in 1930, it wasn't fully enforced until the arrival of Joseph Breen as head of the Production Code Administration in 1934. The depiction of "sex perversion or any inference to it" was explicitly forbidden by the Code. Homosexuality was consistently censored by the Production Code office (as well as by local and religious censorship boards) in both U.S. films and foreign-made U.S. releases. And yet... there are a handful of examples, shown here, that squeaked through one way or another.

Promotional materials on these early films have proved difficult to unearth, but a few are shown here—ranging from the subdued U.S. pitch for the 1931 German lesbian classic *Maedchen in Uniform* to the sensational mania of the 1953 campaign for *Glen or Glenda? (I Changed My Sex)*. These marketing campaigns evolved from the innocuous to the infamous—the '50s ushered in an era of graphic descriptions and hyperbolic promises. This new sense of explicitness anticipated the demise of the Code in 1961 and paved the way for even more depictions of homosexuality in the '60s.

ESSANAY

Essanay
TRADE MARK.
REG. U.S. PAT. OFF.

SWEEDIE'S HERO

 PRESENTING **WALLACE BEERY**

CONTROLLED BY THE ESSANAY FILM M'F'G. CO., CHICAGO, ILL.

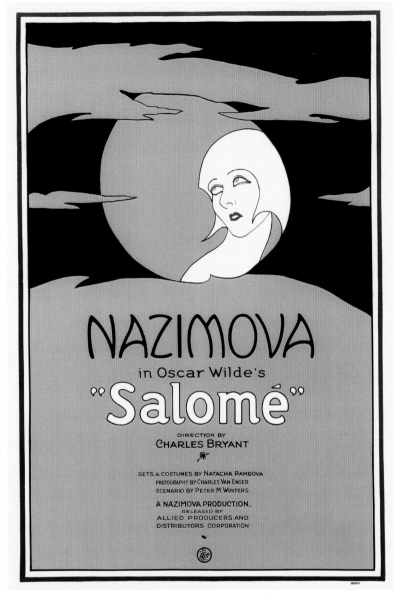

SALOMÉ (1923)

ALLIED PRODUCERS & DISTRIBUTORS CORPORATION

Written and directed by Alla Nazimova as a tribute to Oscar Wilde (but credited to her husband, Charles Bryant), this legendary silent is said to have had an all-gay cast. Its sets and costumes were designed by Nazimova's lesbian lover, Natacha Rambova (who was also the wife of Rudolph Valentino), from illustrations by Aubrey Beardsley. This gorgeous Beardsleyesque poster wonderfully reflects that elusive quality known as "the gay sensibility" (and invoking the name of Oscar Wilde lends it a certain homosexual credibility as well).

SWEEDIE'S HERO (1915)

ESSANAY STUDIOS

Talk about bad drag: Über-butch Wallace Beery first made a name for himself as the star of the wildly successful series of short *Sweedie* comedies for Essanay Studios (which was also home to Charlie Chaplin early in his career). Most of the silent comedians took a stab at drag in these early days, including Charlie Chaplin, Fatty Arbuckle, Harry Langdon, Stan Laurel, Oliver Hardy, and Charlie's brother, Syd Chaplin, who took numerous drag roles throughout the '20s. The *Sweedie* series featured such popular hits as *Sweedie and Her Dog, Countess Sweedie*, and that hilarious favorite *Sweedie's Suicide!*

JOHN KRIMSKY and GIFFORD COCHRAN present

"MAEDCHEN IN UNIFORM"

"See 'Maedchen in Uniform' by all means! It's the best picture I ever saw!"
—WALTER WINCHELL, *Daily Mirror.*

44th STREET THEATRE
44th STREET, WEST OF BROADWAY

TWICE DAILY—2:50 P.M. and 8:50 P.M.
Sundays and Holidays—2:50 P.M., 6:00 P.M. and 8:50 P.M.

Lower prices than any other two-a-day Feature Film on Broadway

ALL SEATS RESERVED	Matinees—.25, .40, .55 and .75 Evenings—.40, .55, .85 and $1.10

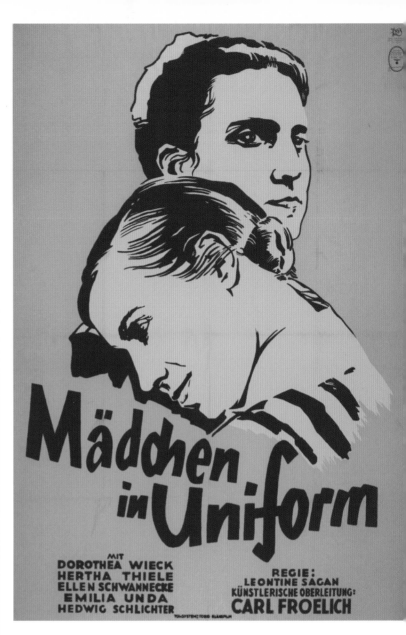

MAEDCHEN IN UNIFORM (1931)

DEUTSCHE FILM GEMEINSCHAFT FILMCHOICE

Note the subdued strategy for the U.S. release (on this original playbill promoting the film's run at the 44th Street Theater) in comparison to the German poster, which features the embrace between the schoolgirl Manuela (Hertha Thiele) and the object of her affections, the teacher Fräulein von Bernbourg (Dorothea Wieck). Considered to be the first lesbian film ever made, *Maedchen in Uniform* was critically acclaimed at its initial release and remains a classic today. The German poster is provided courtesy of the Filmmuseum Berlin—Stiftung Deutsche Kinemathek.

THE SINNERS *(AU ROYAUME DES CIEUX)* (1952)

COMMANDER PICTURES INC.

This obscure French prison drama by Julien Duvivier was originally produced in 1949 but not released in the States until 1952. The French title, *Au royaume des cieux*, translates to "In the Kingdom of Heaven" (which is not nearly as sexy a title as *The Sinners*). Nadine Basile costars as a lesbian prisoner who has "men" tattooed on one leg and "women" on the other. Note the image of the two women about to kiss and the reference to "strange love."

NEVER BEFORE!

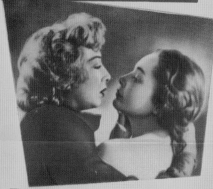

a film so daring...
so frank...so shocking!

"A MAJOR CREATION!"
N. Y. World Telegram

Emotional Secrets Women Only Whisper About

"I put on a tight-fitting satin dress and started walking. It was easy!"

JULIEN DUVIVIER'S SENSATIONAL MASTERPIECE
OF STRANGE LOVE

"THE SINNERS"

Distributed by Commander Pictures, Inc.

"My first love packed up and left. I was in terrible trouble!"

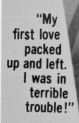

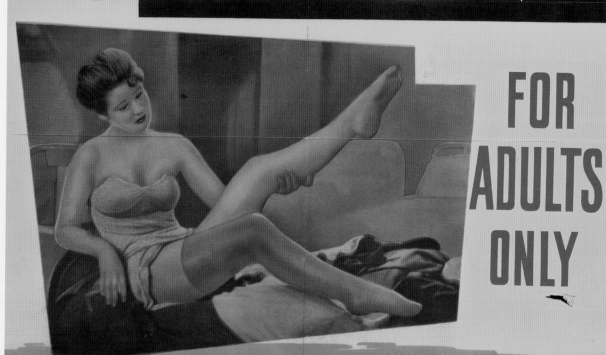

FOR ADULTS ONLY

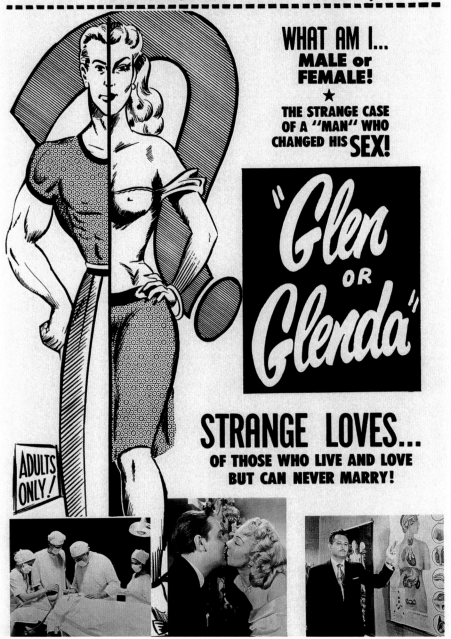

GLEN OR GLENDA? *(I CHANGED MY SEX)* (1953)
SCREEN CLASSICS INC.

Nineteen fifty-three stands out as the biggest year to date for queer releases, with a pair of transsexual-exploitation features hitting the screens at the same time. Both *Glen or Glenda?* and *Children of Loneliness* (a.k.a. *The Third Sex,* not pictured) promise a bizarre world of gender confusion in their ad campaigns. The *Glen or Glenda?* campaign shows us the half-man, half-woman, and echoes *The Sinners* with its reference to "strange loves." *Children of Loneliness* takes a similar tack, building us up with a series of breathlessly sensational taglines and a half-male, half-female face with a question mark in the middle. Both features are clearly Z-grade fare (*Glen or Glenda?* was brought to the screen by Ed Wood Jr., who would later go on to make *Plan Nine from Outer Space,* considered by many to be the worst movie ever made).

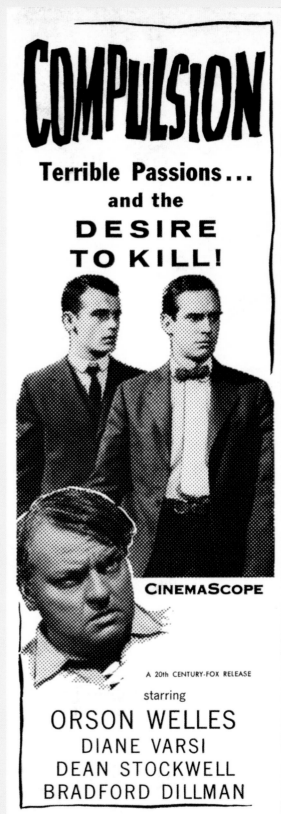

COMPULSION

Terrible Passions...
and the
DESIRE
TO KILL!

CINEMASCOPE

A 20th CENTURY-FOX RELEASE

starring

ORSON WELLES
DIANE VARSI
DEAN STOCKWELL
BRADFORD DILLMAN

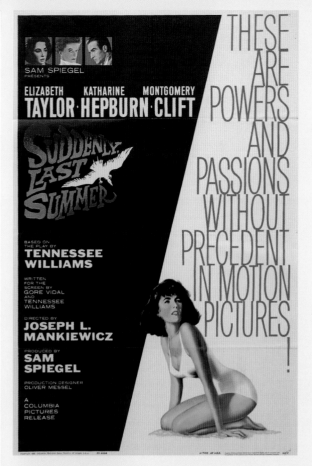

COMPULSION (1959)
20TH CENTURY FOX

SUDDENLY, LAST SUMMER (1959)
COLUMBIA PICTURES

The year 1959 marked the mainstream Hollywood debut of the despicable homosexual lead character. *Compulsion*'s pair of psycho killers (based closely on Leopold and Loeb and portrayed by Dean Stockwell and Bradford Dillman) stand alongside *Suddenly, Last Summer*'s Sebastian Venable as the most irredeemable screen queers in history. Venable is such a horrifying monster that we never actually get to see him on screen in this film version of Tennessee Williams' play about a homosexual who uses his mother (Katharine Hepburn) and then his cousin (Elizabeth Taylor) to attract young men. According to Vito Russo's *The Celluloid Closet*, Sebastian's homosexuality could be "inferred but not shown"—by special permission of the Production Code office. The powerful Legion of Decency, the Catholic Church's monitoring body for motion pictures, gave *Suddenly, Last Summer* a special classification, saying that even though it dealt with sexual perversion, it could be considered moral in theme, "since the film illustrates the horrors of such a lifestyle." The alliterative tagline of the one-sheet seems oddly effeminate in its own right. The half-sheet version (not shown) entices us with the claim, "Suddenly last summer Cathy knew she was being used for something evil." *Compulsion*'s one-sheet (not shown) blares: "You know why we did it? Because we damn well felt like doing it!" (Presumably the *it* in question is meant to refer to the murder, not to the "terrible passions" mentioned in the ad campaign.) As evil as these characters were, they paved the way for the slightly less despicable portrayals of the '60s.

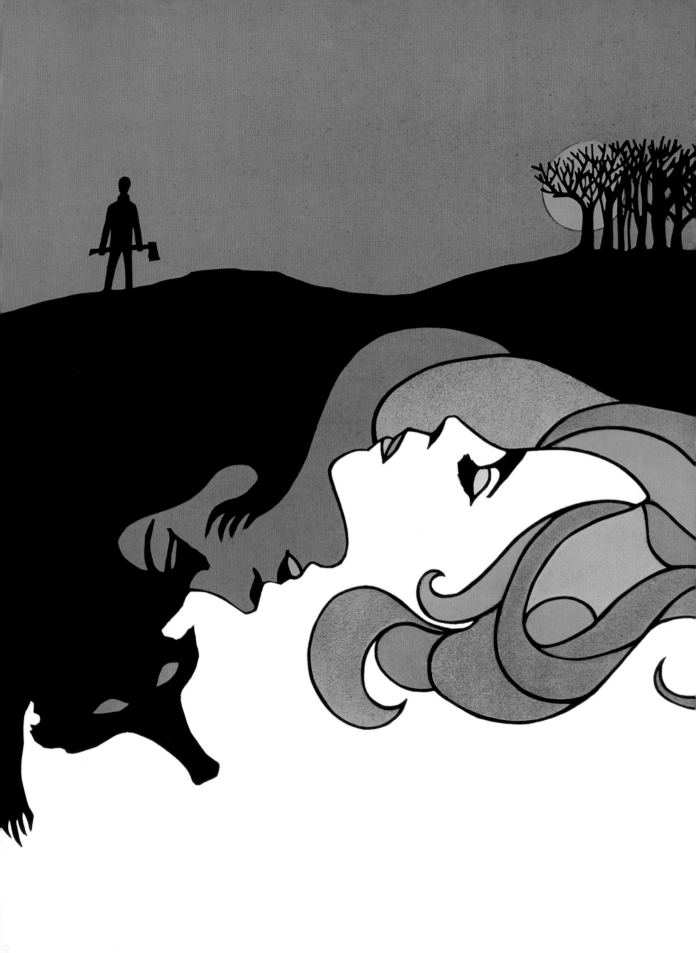

the '60s CHAPTER II

Although the early '60s saw the end of Production Code censorship of "sex perversion," the immediate resulting portrayals were a far cry from the multidimensional, "positive" depictions of GLBT characters we see today. In this decade leading up to the Stonewall Riots of June 1969, homosexuality was generally employed in cinema as a novelty element, a shocking plot twist, a deviant sexual sickness.

Although on-screen homosexuality was no longer forbidden, it was still hugely controversial, and many of the mainstream films released at this time that had gay or lesbian content were rated X. The films themselves consist primarily of homophobic stereotypes of tortured outsiders and psychopaths—and the marketing campaigns played up these elements to the hilt.

From obscure soft-core Dykesploitation to the more well-known and widely seen Hollywood fare of the era, we see the same strategies of subtle (and sometimes not so subtle) innuendo, coy suggestion, pathological implication, smirking contempt, and sensational exposé. The marketing of the '60s is squarely directed at straight audiences, since the nascent community of gays and lesbians was not yet recognized as an audience to be marketed to.

At the end of the '60s and the start of the '70s (corresponding with the increasing visibility and political viability of the gay rights movement, sparked by Stonewall), we see not only a boom in gay-themed film production, but also a shift in the tone of most marketing materials. As shown in this and the following chapter, portrayals of the solitary gay individual give way to depictions of gay community: *The Killing of Sister George* (1968), *The Gay Deceivers* (1969), *The Boys in the Band* (1970), *Some of My Best Friends Are...* (1971). Now we begin to also see a new combination of coyness and whimsy as these campaigns, still clearly directed at heterosexual audiences fascinated with the gay milieu, convey a snickering (and sometimes subversive) humor. The films themselves continue to portray gay life as a pretty sad existence—but at least the gay people now have company in their misery. Of course, there's no question that these films, bleak as they are, entertained gay audiences, who finally had the pleasure of seeing their lives represented on screen.

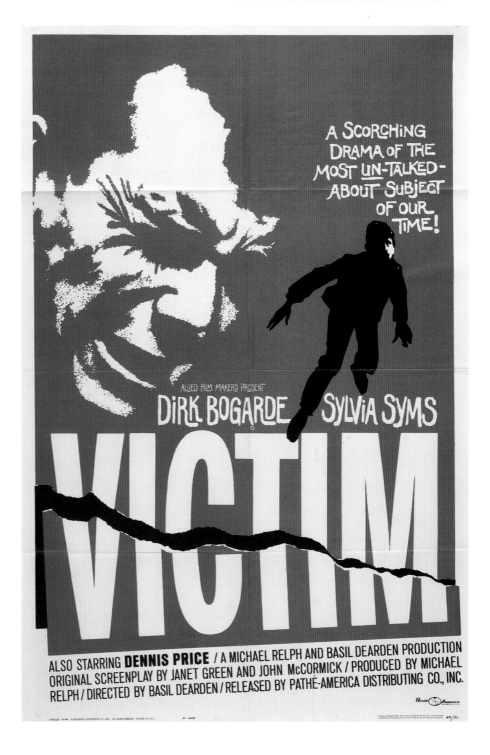

VICTIM (1961)

RANK FILM ORGANIZATION/PATHÉ-AMERICA DISTRIBUTING COMPANY

Representing the love that, literally, "dare not speak its name" strategy is the marketing for the Dirk Bogarde drama *Victim*. This lavender-hued campaign offers a brilliant pitch as it appeals to the prurient interests of the general public and manages to insinuate its subject matter—the systematic blackmailing of homosexuals in England—without ever actually saying what the film is about. (A booming voiceover in the film's preview trailer gives us a hint, asking provocatively, "What crime linked an aging hairdresser and a famous star of the theater?") Note the imprint of Bogarde's grimacing face and the torn effect on the title—both conveying the tortured psychology of the homosexual. The film itself, the first widely released gay drama, is still one of the most powerful gay-themed films ever made.

The Strange Rapport Between Two Boys On The Threshold Of Love...

"Sensitive! The boys are excellent! The development of their relationship—its poetry and its guilt—is well done."
—Frances Herridge, N.Y. Post

"Serious! Tender! Delicate! Jean Delannoy has directed with faithfulness to the subject matter."
—Cue Magazine

"Mr. Delannoy has done a commendable job."
—Bosley Crowther, N.Y. Times

Pathé Contemporary Films presents
Jean Delannoy's

This Special Friendship

THIS SPECIAL FRIENDSHIP
(LES AMITÉES PARTICULIÈRES) (1964)
PATHÉ CONTEMPORARY FILMS

The U.S. ad for this anomalously sympathetic French portrait of budding gay love at a boarding school still manages to utilize the word *strange*.

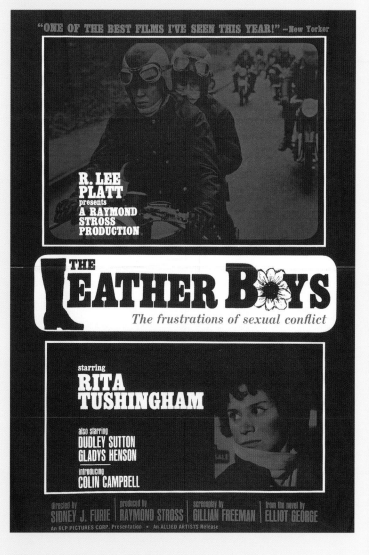

THE LEATHER BOYS (1964)
ALLIED ARTISTS PICTURES CORPORATION

The various campaigns for this film manage to utilize the whole arsenal of gay movie marketing conventions (purple background, torn images, the words *strange triangle*, and even a nice little daisy). While the one-sheet conveys what we might call a subdued sensationalism (tame graphics tone down the words *sexual conflict*), the ad campaign (not shown) goes all out by utilizing three torn images of the film's stars alongside the tagline "Three lives savagely ripped apart." Another ad design describes "restless youth in a strange triangle!" *The Leather Boys* is one of several early '60s British dramas that sensitively incorporate a gay theme—others include *A Taste of Honey* (1961), *The L-Shaped Room* (1962), and *The Family Way* (1966).

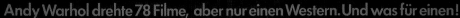
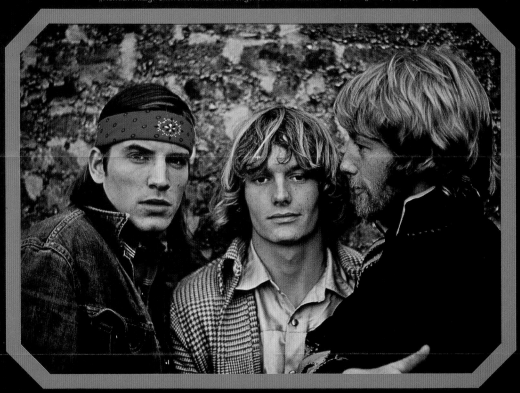

andy warhol's
lonesome

Superstars: Viva! Taylor Mead Louis Waldon · Joe Dallesandro

cowboys

Stars: Tom Hompertz · Eric Emerson · Julian Burroughs · Francis Francine
Regie, Kamera und Produktion: Andy Warhol · Produktionsleitung: Paul Morrissey · Ein Farbfilm der

Constantin-Film

LONESOME COWBOYS (1967)

SHERPIX/CONSTANTIN FILM

This attractively designed German re-release poster spotlights *Lonesome Cowboys'* three hunky stars with the tagline, "Andy Warhol made 78 films but only one Western. And what a Western." The original American one-sheet sassily proclaims: "Andy Warhol's *Lonesome Cowboys* may be a bit too much for many people, but that's their problem."

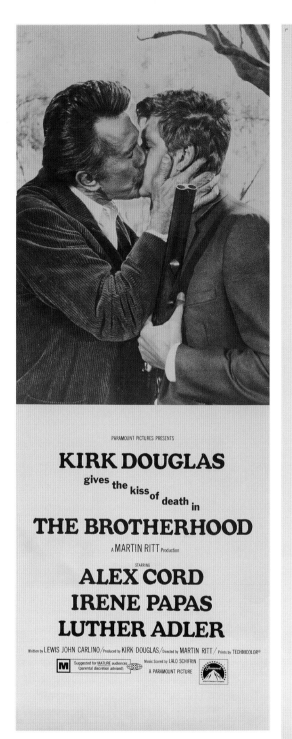

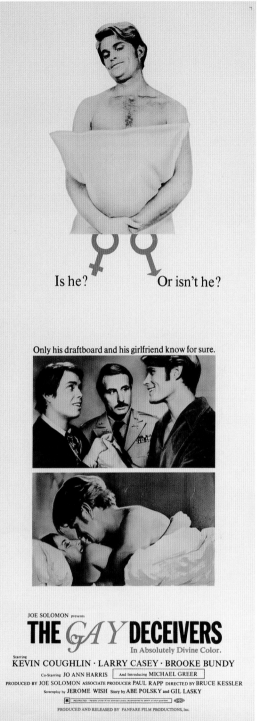

Is he? Or isn't he?

THE BROTHERHOOD (1968)
PARAMOUNT PICTURES

The insert for Martin Ritt's pre-*Godfather* Mafia drama makes the most of a provocative kiss between two men. In his book *Screening the Sexes: Homosexuality in the Movies*, Parker Tyler describes how, on the film's release, "a huge billboard on Times Square displayed the heads of one man kissing another so closely their physiognomies could not be identified." The man bestowing the Mafioso "kiss of death" on his younger brother (Alex Cord) is in fact Kirk Douglas— and the film itself is not at all gay-themed.

THE GAY DECEIVERS (1969)
FANFARE FILMS INC.

This brightly obnoxious comedy is like *Love American Style* gone homo. The beefy blond straight guy with the pillow (Kevin Coughlin) is pretending to be gay (with his straight best friend) to avoid the draft. The wacky tone of the insert reflects the tone of the film itself, which, much like *Staircase* (page 28), goes all out with mincing and swishing for comic effect. Openly gay actor Michael Greer steals the film as the over-the-top flaming landlord.

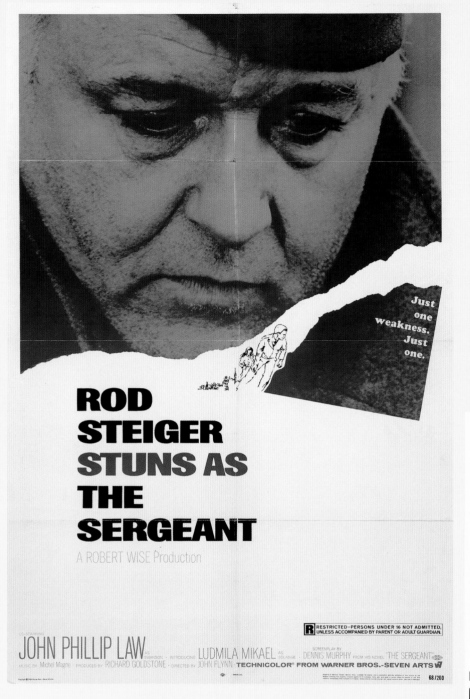

THE SERGEANT (1968)

WARNER BROTHERS/SEVEN ARTS

Rod Steiger's Sergeant Callan is the quintessential tortured homosexual (a very butch guy with a "weakness"). Steiger's character is a closeted homosexual—with a crush on a handsome young private (John Phillip Law). After Steiger's sergeant kisses the private in a burst of uncontrollable passion, he promptly goes off to the woods to shoot himself. Again, notice the torn edge of the poster photo, conveying the sergeant's psychological struggle; the ad slick goes even farther. Note also the purple background on the poster.

Rome.
Before Christ.
After Fellini.

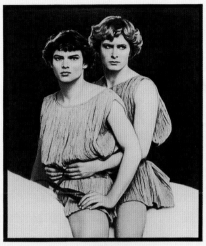

"There is no end, no beginning.
There is only the infinite passion of life."
—FELLINI

An ALBERTO GRIMALDI Production
"FELLINI SATYRICON"

starring
MARTIN POTTER · HIRAM KELLER · MAX BORN · SALVO RANDONE · MAGALI NOËL
ALAIN CUNY · LUCIA BOSE · TANYA LOPERT · GORDON MITCHELL with CAPUCINE
Story and Screenplay by FEDERICO FELLINI and BERNARDINO ZAPPONI
COLOR by DeLuxe® PANAVISION® United Artists
 Entertainment from
 Transamerica Corporation

SATYRICON (1969)

UNITED ARTISTS

The U.S. poster campaign for Federico Fellini's polymorphously perverse Italian bacchanal features two men together on the one-sheet (pictured), two women about to kiss on the half-sheet, and two men in bed with a woman on the insert.

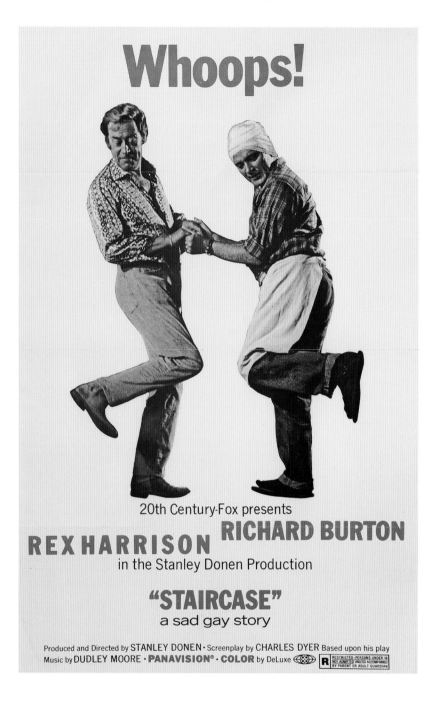

STAIRCASE (1969)
20TH CENTURY FOX

Talk about shock value. The full ad campaign for this Richard Burton/Rex Harrison self-loathing homo melodrama shows a photo of the pair in bed together and asks, "Can this marriage last?" Underneath the title we see the answer: "Staircase: A Sad Gay Story." The teaser campaign plays up the ludicrous idea that these two paragons of masculinity would be seen in such a film: "Richard Burton & Rex Harrison Play WHAT?" The lovely pink-and-pale-yellow one-sheet pictured here simply portrays the pair in a mincing skip. The caption "Whoops!" presumably suggests either their effeminacy or the idea that homosexuality is some accident of nature. Contemporary audiences looking beyond the dense layer of homo-hatred that envelops the film can feel an intense sympathy for these characters, who are trapped in a pre-Stonewall Cinemascope rendering of an intensely homophobic stage play. The film was directed by Stanley (*Singin' in the Rain*) Donen.

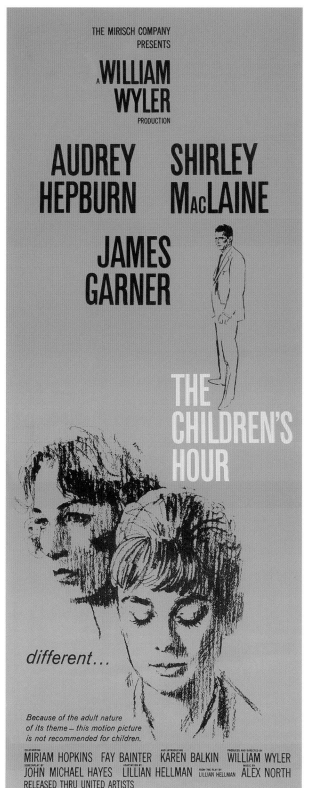

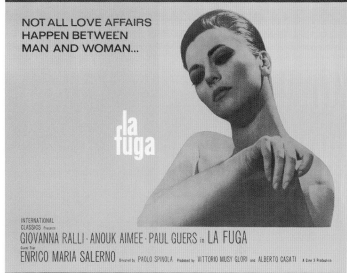

LA FUGA *(THE ESCAPE)* (1966)
INTERNATIONAL CLASSICS INC.

A little humor and subtlety come as a welcome relief right about now. Released in the United States as *The Escape* and in Germany as *Liebe im Zwielicht (Love in Twilight)*, this Euro love triangle stars Paul Guers as the husband, Giovanna Ralli as the wife, and Anouk Aimée as the other woman.

THE CHILDREN'S HOUR (1961)
UNITED ARTISTS

From the downcast and averted eyes of Shirley MacLaine and Audrey Hepburn on this lavender insert, we can see that being "different" is not something that makes them feel proud. United Artists designed numerous shocking ad campaigns for Hollywood's first lesbian drama—a screen adaptation of Lillian Hellman's powerful play of the same name. Promo text included: "The child's accusation was too evil to be false... too shocking to be true!" And, "There is a whisper that can make a love more tender... and a whisper that can tear a love apart... " The teaser campaign for the film utilized two-inch ads that proclaimed, "The Children's Hour is not for children!" accompanied by a gigantic exclamation point. Although the marketing for the film clearly strikes a lurid chord and Shirley MacLaine's Martha ends up a suicide, *The Children's Hour* paved the way for the future of GLBT characters on the American screen. The film was released in December 1961, just two months after the Motion Picture Association of America had announced the removal of "sex perversion" from the list of subjects forbidden by the Production Code. For a fascinating, detailed history of the fall of the Code (and the role that *The Children's Hour* played in its demise), see Vito Russo's *The Celluloid Closet*.

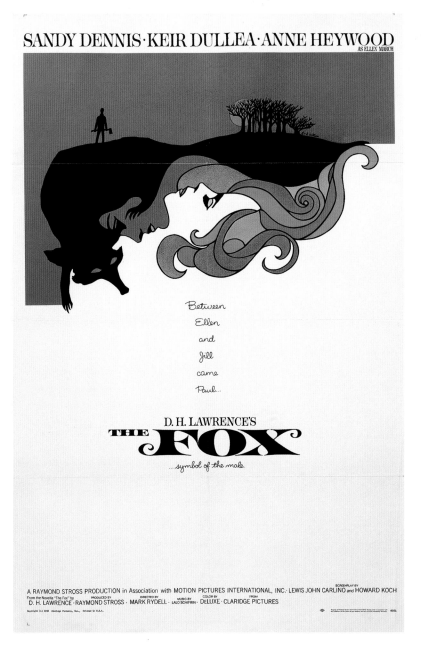

SANDY DENNIS · KEIR DULLEA · ANNE HEYWOOD
AS ELLEN MARCH

*Between
Ellen
and
Jill
came
Paul...*

D. H. LAWRENCE'S
THE FOX
...symbol of the male

A RAYMOND STROSS PRODUCTION in Association with MOTION PICTURES INTERNATIONAL, INC.· LEWIS JOHN CARLINO and HOWARD KOCH
From the Novella "The Fox" by PRODUCED BY DIRECTED BY MUSIC BY COLOR BY FROM
D. H. LAWRENCE · RAYMOND STROSS · MARK RYDELL · LALO SCHIFRIN · DELUXE · CLARIDGE PICTURES

THE FOX (1968)
CLARIDGE PICTURES

The optical-illusion line drawing makes its debut here and becomes a convention of lesbian film posters of this era (see *The Killing of Sister George*, facing page, and also *That Tender Touch*, page 39). The line drawing represents two women, lying one atop the other, as well as the rural terrain where Ellen and Jill (Anne Heywood and Sandy Dennis) make their home (with the ominous, ax-wielding Keir Dullea/Paul on the horizon). The insert version (not shown) takes a similar approach, with a keyhole in the shape of a foxtail through which we see the women kissing. The creepy ad campaign shows us photos of Anne Heywood first with Sandy Dennis and then in bed with Keir Dullea ("Ellen didn't know who she was or what she was… with Jill she was one thing… with Paul another… "). Of course, Jill ends up dead under a felled tree (that's where the ominous ax comes in), and Ellen goes off with Paul in the end.

THE KILLING OF SISTER GEORGE (1968)
PALOMAR PICTURES/CINERAMA

This one-sheet's sensational tagline offers a shocking lesbian triangle as compelling entertainment for pre-Stonewall audiences. Beryl Reid portrays the aging butch soap-opera actress trying to hang on to her career and her baby-doll femme lover (Susannah York) as the predatory BBC executive Coral Browne threatens to sack her and steal her girl in this predictably lurid Robert Aldrich saga. Here the line drawing represents a woman's body morphing into a woman's face.

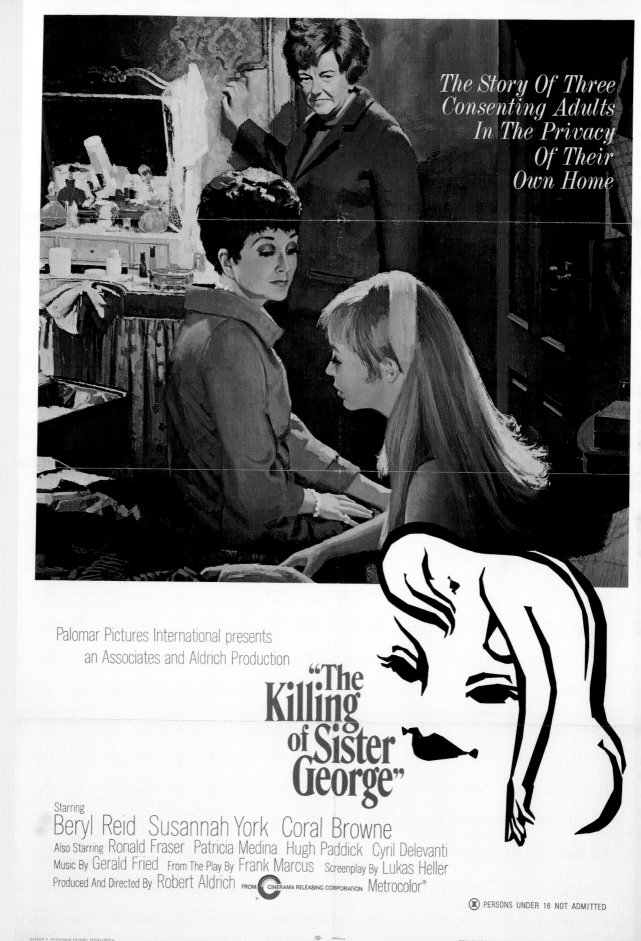

The Story Of Three
Consenting Adults
In The Privacy
Of Their
Own Home

Palomar Pictures International presents
an Associates and Aldrich Production

"The Killing of Sister George"

Starring
Beryl Reid Susannah York Coral Browne
Also Starring Ronald Fraser Patricia Medina Hugh Paddick Cyril Delevanti
Music By Gerald Fried From The Play By Frank Marcus Screenplay By Lukas Heller
Produced And Directed By Robert Aldrich FROM CINERAMA RELEASING CORPORATION Metrocolor®

(X) PERSONS UNDER 16 NOT ADMITTED

69/81

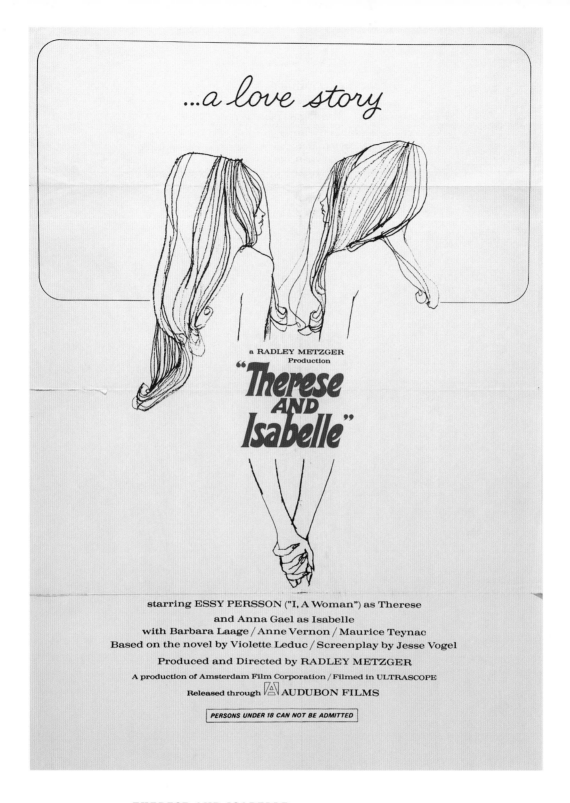

...a love story

a RADLEY METZGER
Production

"Therese
AND
Isabelle"

starring **ESSY PERSSON** ("I, A Woman") as Therese
and **Anna Gael** as Isabelle
with Barbara Laage / Anne Vernon / Maurice Teynac
Based on the novel by Violette Leduc / Screenplay by Jesse Vogel
Produced and Directed by RADLEY METZGER
A production of Amsterdam Film Corporation / Filmed in ULTRASCOPE
Released through [A] **AUDUBON FILMS**

PERSONS UNDER 18 CAN NOT BE ADMITTED

THERESE AND ISABELLE (1968)
AUDUBON FILMS/FIRST RUN FEATURES

Again with the line drawing. The simplicity of this U.S. one-sheet campaign actually manages to convey a considerable amount of dignity and respect for its characters. The ad designs are not quite so dignified, touting "the strangest love story ever told." Director Radley Metzger did a terrific job on this gorgeous Cinemascope schoolgirl love story, based on a novel by Violette Leduc.

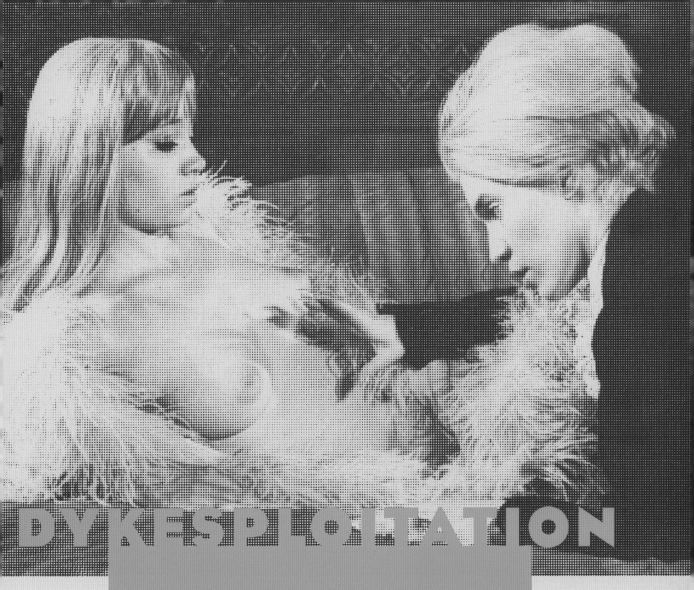

DYKESPLOITATION

Girl-on-girl action has always been one of the staples of straight porn and erotica. Hundreds of trashy lezzie/bi-girl swinging features were churned out in the '60s and '70s, before the rise of hard-core porn. We wouldn't exactly embrace these films as positive portrayals of lesbian or bi life (like their Hollywood counterparts, the exploitation studios had little sympathy for their dyke protagonists). But from our current historical distance, these trashy gems offer loads of campy entertainment value. You've never seen so many exclamation points!... and ellipses... in your life!

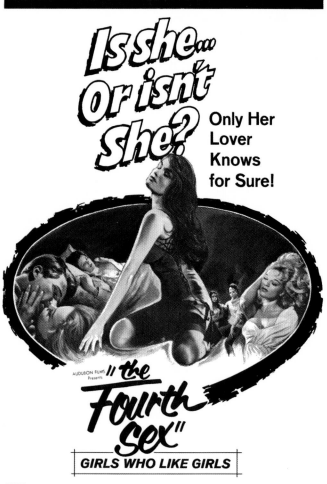

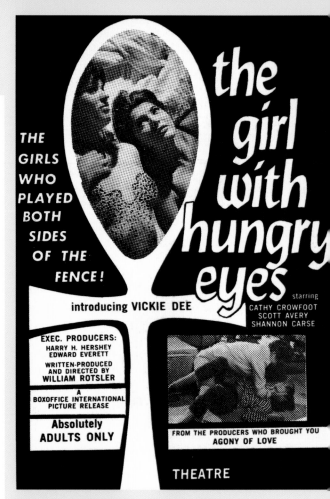

THE GIRL WITH HUNGRY EYES (1967)
BOXOFFICE INTERNATIONAL PICTURES

Just like most Hollywood films of old, the exploitation genre tended to kill off its queer protagonists. This melodrama has Tigercat (Cathy Crowfoot) preying on vulnerable young Kitty (Vickie Dee), who eventually goes back to her boyfriend, Brian, after a thorough tour of the lesbian underworld. In the end Brian kills Tigercat, and, the press book tells us, "Kitty eagerly picks up her membership card in the female sex, finding it in Brian's arms." The Kitty-type character is the classic device used in the Dykesploitation genre to provide us access to the world of lesbianism. Kitty is, of course, not a real lesbian (she was just playing "both sides of the fence").

THE FOURTH SEX *(LE QUATRIÈME SEXE)* (1961)
AUDUBON FILMS

This early example of Dykesploitation marketing manages to be both refreshingly straightforward ("girls who like girls") and maddeningly oblique ("is she or isn't she" *what?*). The press book explains that Sand (Brigitte Juslin) is an American lesbian in Paris who seduces Caroline (Nicole Burgeot) and is in turn seduced by Caroline's brother, Michel (Richard Winckler), who calls her "the Fourth Sex." In the end (when she goes off with Michel), we learn the answer to the question: she "isn't" a lesbian! Audubon Films released an abundance of lesbian and swinging Euro soft-core over the years, including such greats as *Her, She & Him* ("A motion picture deviation"), *The Lickerish Quartet* ("An erotic duet for four players"), and *Therese and Isabelle* (see page 32).

CHAINED GIRLS (1965)
AMERICAN FILM DISTRIBUTING CORPORATION

The press book for this film is possibly the greatest queer press book ever created. Here you see it in its entirety. What else can we say, except: enjoy!

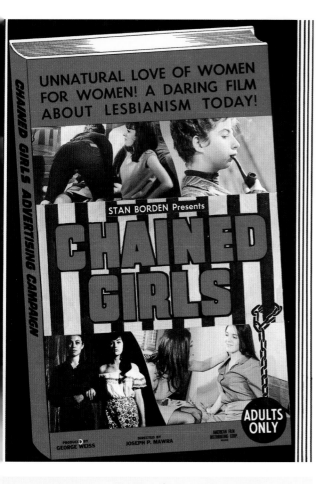

CHAINED GIRLS ADVERTISING CAMPAIGN

UNNATURAL LOVE OF WOMEN FOR WOMEN! A DARING FILM ABOUT LESBIANISM TODAY!

STAN BORDEN Presents

CHAINED GIRLS

ADULTS ONLY

PRODUCED BY GEORGE WEISS
DIRECTED BY JOSEPH P. MAWRA

AMERICAN FILM DISTRIBUTING CORP.

THE FREQUENCY OF LESBIAN RELATIONS INCREASES FROM

2 times a week in age group 16-20
to 4 times weekly in age group 26-30
to 6 times weekly in age group 36-40

AMONG TEEN AGE GIRLS
40%
HAVE LESBIAN DESIRES . . .
AND EXPERIENCES

Only through understanding the facts, can we keep Lesbianism from becoming a serious social problem!

The characters portrayed in this film are depicted by professionals. Any scenes or situations relating to living persons are purely coincidental.

Conditions That Cause Lesbianism . . .
HATRED FOR AGGRESSIVE, DOMINATING MOTHER!
UNFOUNDED HATRED OF ALL MEN!
FEAR OF BEARING CHILDREN IN MARRIAGE!
NEUROTIC FEAR OF MARRIAGE!

90% OF FEMALES WITH PREVIOUS LESBIAN EXPERIENCE WILL CONTINUE THIS SEXUAL DEVIATION!

71% RESTRICT THEIR ACTIVITY TO A LONE PARTNER

37% OF LESBIANS ARE MARRIED!

10% PREVIOUSLY MARRIED, WIDOWED OR DIVORCED

10% OF FEMALES AGE 26-30 HAVE LESBIAN AFFAIRS

24% OF SINGLE GIRLS AT AGE 30-35 ARE LESBIANS

28% OF LESBIANS ARE 45 YEARS — OR OLDER

25% OF COLLEGE GIRLS HAVE HAD A LESBIAN EXPERIENCE

33% OF FEMALE SINGLE COLLEGE GRADUATES ARE LESBIANS!

FEMALE DEVIATION IN NORMAL SEXUAL BEHAVIOR GREATLY EXCEEDS THE MALE

TABLE OF CONTENTS

A FILM SO DARING...SO HUSH-HUSH...IT WILL BRING REPEAT BUSINESS TO YOUR THEATRE!

THE DYKE THE QUEEN BABY BUTCH PART TIME LEZ

CATCH LINES THAT SELL TICKETS

- SHACKLED WOMEN IN UNASHAMED LOVE MAKING!
- UNCHAINED DESIRES LOOSENED FOR UNHOLY CRAVINGS!
- GUILTY SEX RELATIONS — WARPED AND FORBIDDEN!
- TORTURED BY A SOCIETY THAT FORBIDS THEIR DESIRES!
- TORMENTED GIRLS — EASY VICTIMS OF UNNATURAL LOVE!
- GIRL MEETS GIRL — GIRL LOVES GIRL — GIRL MARRIES GIRL!
- DISCIPLES OF THE DEVIL — TAUGHT AN UNNATURAL LOVE!
- ONE OUT OF FIVE — IS A CHAINED GIRL!
- A WARNING TO PARENTS — ENLIGHTEN YOUR DAUGHTER!

RUNNING TIME: 65 MINUTES

PRODUCTION CREDITS

GEORGE WEISS
Producer

JOSEPH P. MAWRA
Director

HAROLD CASANOVA
Greenwich Village Photo

PERRY PETERS
Narration

WERNER ROSE
Apartment Sequence

MAGNO SOUND
Sound

ALL SERVICE
Laboratory

NOTE: Because of the tenuous theme of "Chained Girls" all cast names have been withheld by the producer!

This Press Book has Been Prepared and Written by GEORGE WEISS

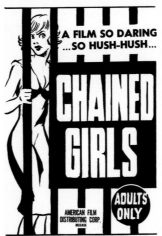

A FILM SO DARING ...SO HUSH-HUSH...

CHAINED GIRLS

ADULTS ONLY

AMERICAN FILM DISTRIBUTING CORP. RELEASE

Mat 201

A FILM SO DARING ...SO HUSH-HUSH...

CHAINED GIRLS

ADULTS ONLY

Mat 101

CHAINED GIRLS

ADULTS ONLY

AMERICAN FILM DISTRIBUTING CORP. RELEASE

Mat 202

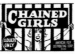

CHAINED GIRLS

ADULTS ONLY

AMERICAN FILM DISTRIBUTING CORP.

Mat 102

ACCESSORIES AVAILABLE

ONE SHEET • STILLS
AD MATS
TRAILER
8 x 10
11 x 14 } EMBOSSED TITLE CARDS

ORDER ADVERTISING FROM

AMERICAN FILM DISTRIBUTING CORP.

20 EAST 46th STREET, NEW YORK, N. Y. 10017

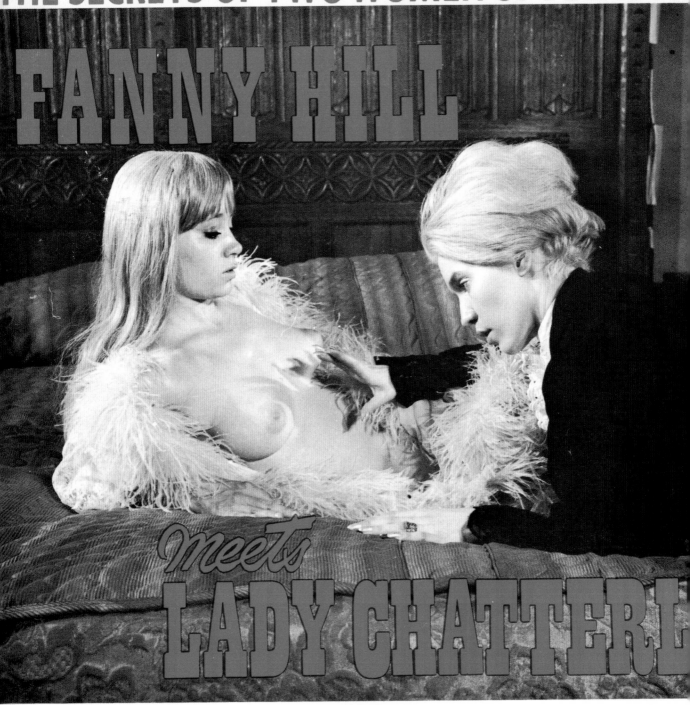

THE SECRETS OF TWO WOMEN OF PLEASUR

FANNY HILL

meets LADY CHATTERL

**THEIR
NOTORIOUS STORIES
BECOME
A SENSATIONAL
MOTION
PICTURE!**

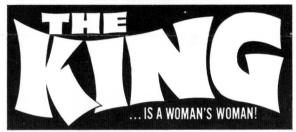
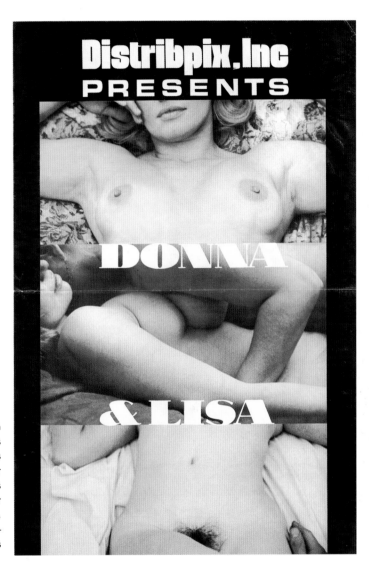
THE KING (CIRCA 1968)
AMERICAN FILM DISTRIBUTING CORPORATION

Interestingly, some of these films make visible the existence of an actual lesbian community. *The King* was shot on Fire Island and is unique within the genre for not having a male antagonist/hero. Its portrayal of a butch lesbian (not generally the biggest turn-on for straight male audiences) is also unusual, though the image of her is barely discernible in the ads since her hair is covering her face. After much salacious detail about the film's lesbian ménage à trois theme, the press book goes on to inform us that "this picture will shock viewers into a better acceptance and understanding about one of today's major social problems."

FANNY HILL MEETS LADY CHATTERLY (1967)
CHANCELLOR FILMS

Here's a wonderful example of the lengths to which the exploitation film industry would go to come up with any conceivable pretext for a new movie. Other films in this series have Fanny Hill meeting "Dr. Erotico" and the Red Baron. After making scads of soft-core in the '60s, director Barry Mahon went on to produce and direct children's films, such as *Santa and the Ice Cream Bunny* (1972), *Thumbelina* (1970), and *Jack and the Beanstalk* (1970).

DONNA AND LISA (1969)
DISTRIBPIX INC.

This film is notable for its excessive array of ad taglines ("Two women trapped in a man's world. Too many men drew them closer together. To them love was something different. Donna was alone until she found Lisa. Her bondage became her pleasure. They did it because they had to"). The taglines reflect another classic Dykesploitation trope: lesbianism as a respite from the brutality of men. In this case, Lisa is a sex slave captive to the violent Sam. She finds tenderness with Donna, only to be murdered by Sam when she finally tries to escape him. The ads themselves are surprisingly dull, but the cover of the press book (seen here) is actually quite nicely done.

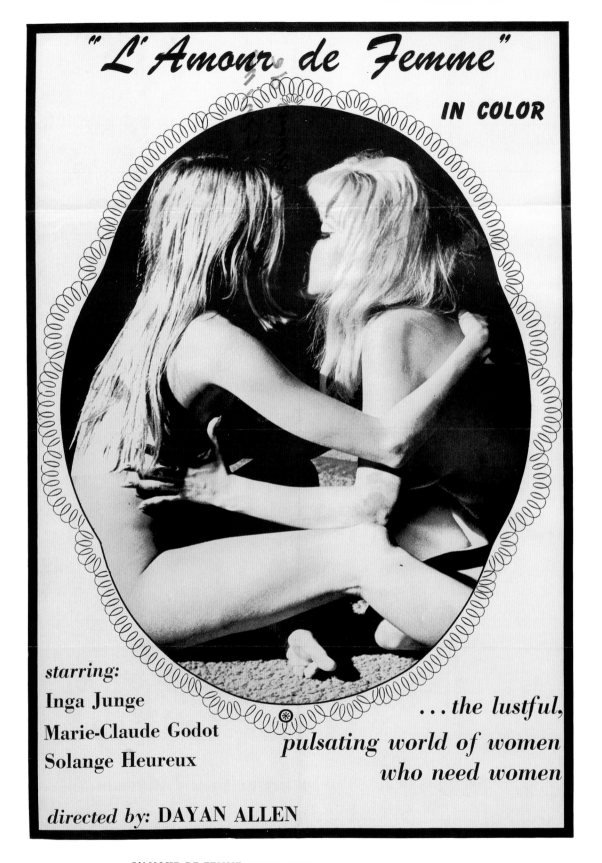

L'AMOUR DE FEMME (CIRCA 1969)

A quintessential one-sheet of the genre: two naked blondes kissing, a smutty tagline, and a suggestive French title (which translates to *A Woman's Love*).

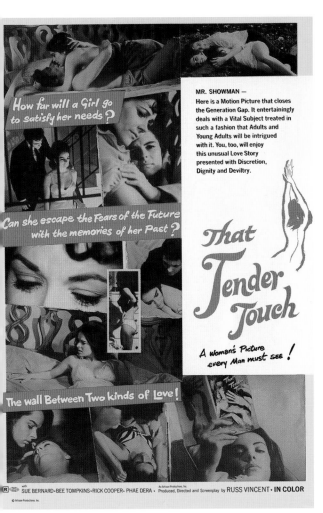

THAT TENDER TOUCH (1969)

ARTISAN PRODUCTIONS INC.

"Another variation on the lesbian thing" is how *Variety* described this tragic lesbian melodrama, which came out on the heels of a slew of more widely released lesbian fare *(Les biches, The Killing of Sister George, The Fox, Therese and Isabelle)*. Again, we have the real lesbian (Bee Tompkins as the doomed Marsha) losing her bi-curious love object (Sue Bernard as Terry) to a man. Note the line-drawing illustration, which echoes the campaigns of other lesbian releases of the era. Amazingly, the film's press book mentions "several national organizations whose members are male or female homosexuals," including the Daughters of Bilitis, the Homosexual Information Center, and the Tangent Group. The press book suggests marketing to these groups, who are "participating in drives to get punitive measures changed." This apparently sympathetic tone is undercut by an accompanying piece (headlined, "Parents, Daughters Should See 'Tender'") that is about marketing the film to younger viewers, who "should know the pitfalls that can lead to abnormal sexuality." Writer-director Russ Vincent goes so far as to say, "I've shown this film to our daughters, and both their mother and I hope they will profit by it."

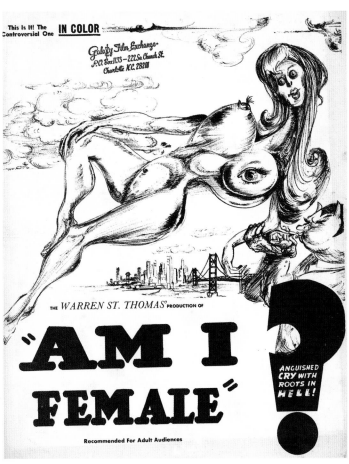

AM I FEMALE? (1970)

CALIFORNIA CONTINENTAL CINEMA

Here's a great example of violent misogyny and lesbophobia in the guise of mere pornography. The title and taglines suggest a theme of transsexualism but actually betray a confusion about the difference between gender identity and sexual orientation. This is even more evident in the press book notes, most of which appear to have been handwritten by a psychopath. A young woman, who had been having sex with both men and women, commits suicide in San Francisco. Her father seeks revenge by murdering "lesbian women that had any connection with his daughter." We are promised a "modern-day sex-oriented Jack the Ripper story."

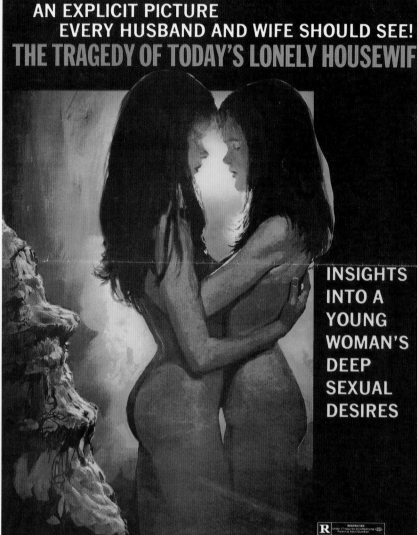

AN EXPLICIT PICTURE
EVERY HUSBAND AND WIFE SHOULD SEE!

THE TRAGEDY OF TODAY'S LONELY HOUSEWIF

INSIGHTS INTO A YOUNG WOMAN'S DEEP SEXUAL DESIRES

HARRY NOVAK PRESENTS

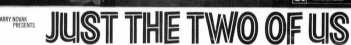

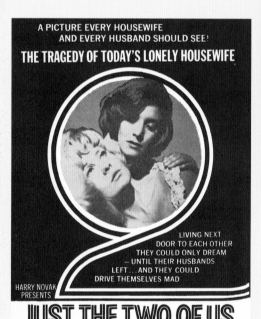

A PICTURE EVERY HOUSEWIFE
AND EVERY HUSBAND SHOULD SEE!

THE TRAGEDY OF TODAY'S LONELY HOUSEWIFE

LIVING NEXT DOOR TO EACH OTHER THEY COULD ONLY DREAM — UNTIL THEIR HUSBANDS LEFT...AND THEY COULD DRIVE THEMSELVES MAD

HARRY NOVAK PRESENTS

JUST THE TWO OF US

STARRING ELIZABETH PLUMB · ALICIA COURTNEY · JOHN APREA · DIRECTED BY BARBARA PEETERS · PRODUCED BY D. NOVIK
IN COLOR A BOXOFFICE INTERNATIONAL PICTURE

JUST THE TWO OF US (1973)
BOXOFFICE INTERNATIONAL PICTURES

Here's another housewife love story, in which one of the women is a real lesbian and the other is just exploring. The film used two campaigns: the racy "two naked girls about to kiss" illustration was campaign #1, and the slightly toned-down "two women swooning together" photo was campaign #1A. Note that the words *explicit* and *sexual* are absent from #1A. Instead, they "drive themselves mad!" (This is actually a decent movie—a pair of housewives fall into bed together after seeing a lesbian couple holding hands at a restaurant on Sunset Boulevard.)

WE DO IT (1970)
MITAM PRODUCTIONS

A precursor to lesbian chic? Here's an example of a swinging exploitation picture that is not about lesbianism but utilizes a lesbian image to get the guys in the door (the film is actually about a pair of housewives who are sex slaves to a bartender named Harry).

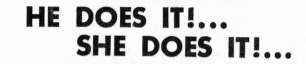

EASTMANCOLOR

HE DOES IT!...
SHE DOES IT!...

WE
DO
IT!

and
EVERYBODY
DOES IT!

•

ADULTS
ONLY

the '70s

While the Stonewall Riots signaled a new era for queers, change did not happen overnight. The status quo of homophobic stereotypes prevailed in Hollywood, prompting a landmark meeting in the summer of 1973 between New York's Gay Activist Alliance (GAA) and the Association of Motion Picture and Television Producers. The GAA protested Hollywood's treatment of gay and lesbian characters and issued the association a list entitled "General Principles for Motion Picture and Television Treatment of Homosexuality." Gay films of the early '70s, and their accompanying marketing campaigns, did begin to reflect incremental progress as gay filmmakers took up their cameras and pioneered their own independent-film movement. Meanwhile, the nascent gay porn industry was bringing out such pioneering all-male sex films as *Boys in the Sand* (1971) and *Adam & Yves* (1974). And Hollywood finally discovered transsexuals and bisexuals as sensational screen fodder and began cranking out crappy movies about swingers and sex changes.

The late '70s and early '80s also marked the beginning of a steady stream of gay foreign-language film releases in the U.S. This coincided with the growth of gay film festivals in New York City, San Francisco, and Los Angeles, as well as several other cities around the world with large gay populations. These festivals were started mostly by gay men with a passion for film and a belief in the importance of seeing gay images on screen. Then, as now, the majority of films being made portrayed gay men's stories, while lesbian-themed films were few and far between (a fact that mirrors the realities of the film industry in general: male directors and stories about men have always been predominant). The '70s were an abysmal decade for lesbian cinema, with only a small handful of foreign-made films getting to the screen (and those were shown mostly at film festivals). The sole representative here, *Bilitis* (1977), was clearly produced for a straight male audience.

The decade culminated with the huge popularity of *La Cage aux folles* (1978), a French farce that clearly amused more than just the art-house crowd and showed that gay-themed films could indeed be financially successful at the box office.

Today is Harold's birthday. This is his present.

MART CROWLEY'S

"THE BOYS IN THE BAND"

...is not a musical.

Written and Produced by Mart Crowley · Executive Producers Dominick Dunne and Robert Jiras · Directed by William Friedkin

A Leo Productions, Ltd. Production · A National General Pictures Release · Color by Deluxe **R** RESTRICTED Under 17 requires accompanying Parent or Adult Guardian

A Cinema Center Films Presentation

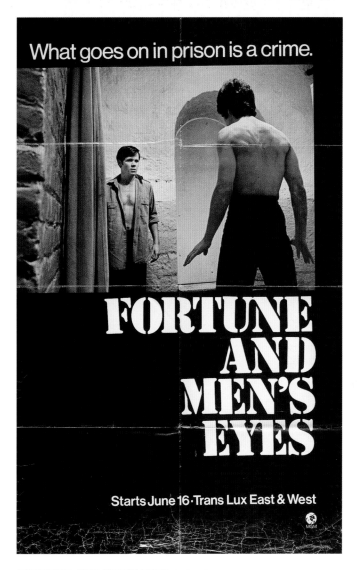

FORTUNE AND MEN'S EYES (1971)
METRO-GOLDWYN-MAYER

A picture is worth a thousand words (and is helped by a provocative tagline). Thirty years before HBO's brutal homoerotic prison drama *Oz*, this U.S.-Canadian coproduction, based on the John Herbert stage play, brought to life the violent homo/sexual realities of life behind bars. Openly gay actor Michael Greer (*The Gay Deceivers*; page 25) stunned audiences with his performance as a bitchy drag queen named Queenie, a role he had performed more than four hundred times in Sal Mineo's original Los Angeles stage production. The poster here is slightly larger than a one-sheet and was specially made for the film's opening in New York and Los Angeles.

THE BOYS IN THE BAND (1970)
NATIONAL GENERAL PICTURES

The *Boys* campaign features yet another coy one-liner capitalizing on the humorous novelty value of gayness: "Today is Harold's birthday. This is his present." The comic but somewhat slimy tone of the campaign reflects the tone of the film itself (penned by gay playwright Mart Crowley from the original stage play) and is reflective of the era in which it was made. In spite of (and because of) its negative portrayal of gay life, this is one of the great gay campfests of all time—a true classic that every newly out homosexual should be required to watch. In his *Screening the Sexes*, Parker Tyler describes the film simply as "a bible of homosexual manners."

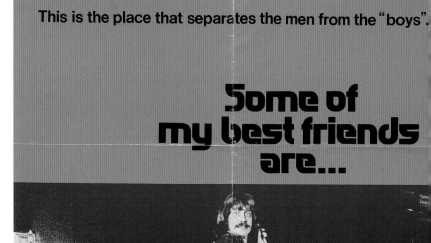

This is the place that separates the men from the "boys".

Some of my best friends are...

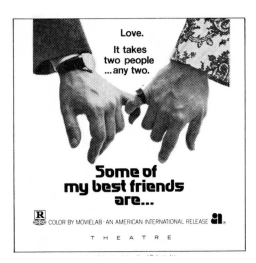

Love.
It takes
two people
...any two.

**Some of
my best friends
are...**

R COLOR BY MOVIELAB · AN AMERICAN INTERNATIONAL RELEASE

T H E A T R E

SOME OF MY BEST FRIENDS ARE... (1971)

AMERICAN INTERNATIONAL PICTURES

Released on the heels of the 1969 Stonewall Inn Riots, which sparked the modern gay and lesbian liberation movement, *Some of My Best Friends Are...* plays up the shock value of its subject matter (a crazy portrait of the patrons of a gay bar on Christmas Eve) but also shows a more radical edge. One ad (featuring an image of a fey hand grasping another guy's hand across a table) manages to wink at the gay audience while coyly poking fun at them for a straight viewer: "Boys... will be boys." Similarly, the ad pictured here has an edge of mockery while making quite a bold statement. It all depends on how you read it. The preview trailer insists that the film is so shocking and graphic that it must "refrain from showing scenes" from the film itself.

HIDDEN PLEASURES
(LOS PLACERES OCULTOS) **(1977)**
AZTECA FILMS

This daring Spanish drama about a fortyish banker with a crush on a teenager was the first sympathetic gay film to emerge from post-Franco Spain. The wildly sensational Spanish-language ad campaign includes such taglines as "One in twenty men are homosexual. Do you understand this problem? A new and difficult theme in cinema!"

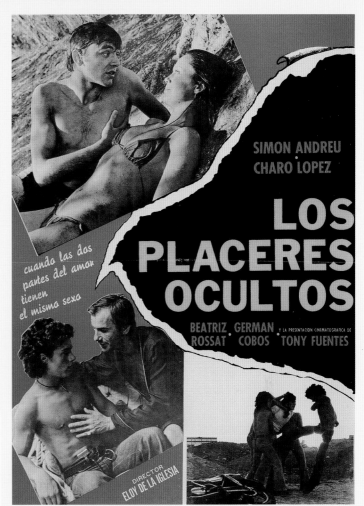

"A MOVIE TO MAKE YOU REMEMBER YOUR OWN LOVES, WHATEVER YOUR PARTNER PREFERENCES ...an eye-opener and a heart opener."
— Norma McLain Stoop, AFTER DARK

"SENSITIVE AND REALISTIC IN ITS APPROACH... IMPRESSIVELY NATURAL."
— A. H. Weiler, N. Y. TIMES

David & Jason's relationship... it's the same only different.

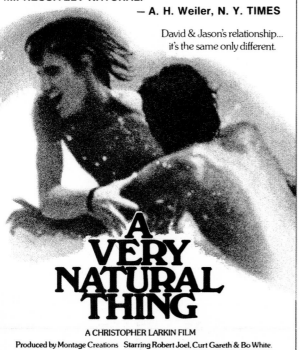

A VERY NATURAL THING (1974)
NEW LINE CINEMA

Even the gay indies use the word *different* in their ad campaigns, but note the pioneering image of two shirtless men embracing. An obscure milestone in gay cinema, *A Very Natural Thing* was the first American gay feature written and directed by a gay filmmaker to get a theatrical release (from New Line Cinema, then a small independent studio best known for its *Friday the Thirteenth* line of horror films). *A Very Natural Thing*'s low-budget production values don't detract from the genuineness of its appeal: the film is a straightforward story about gay relationships that was far ahead of its time.

WORD · IS · OUT

stories · of · some · of · our · lives

Graceful, funny and often very moving... artfully evoked into nothing more than a very and tender little surprise... At times extremely romance, full of people gently reminiscing about what it was like to fall in love for the first time... The one thing they seem to have in common—something that makes the film particularly attractive—is a kind of confidence and certainty, the ability to speak matter-of-factly and behave with firm conviction... At a preview screening there wasn't a dry eye in the house.

Janet Maslin, The New York Times

An affectionate, stirring, and surprisingly witty film... If you put these people in a room, you would have a bizarre clash of ages, classes, attitudes and life-styles. Put them side by side in a movie together, where they discuss their childhoods, first loves and the often painful road to self-acceptance, and you have a remarkably coherent chronicle of what it is like to grow up "different" in America... As the title makes clear, this documentary has a message to spread but it's a good one. There is no way of life, only lives.

David Ansen, Newsweek

A stunning documentary that not only shatters gay stereotypes but also challenges the oppressiveness of the traditional concepts of masculinity and femininity that affect heterosexuals as well as homosexuals. "Word is Out" addresses itself not merely to the country's most castigated and least understood minority, which surely will take heart from it, but to the widest general audience possible. Free of the sensational and full of humor as well as pathos, "Word is Out" is unquestionably a landmark film.

Kevin Thomas, Los Angeles Times

A remarkable cinematic achievement... the film presents a healthy, happy, often touching and frequently funny cross-section of gay America... The message is obvious and powerful. we are everywhere doing everything everyone else does. We dream the same dreams, experience the same past, experience the same frustrations and joys. I have seen the film four times and there are still moments which touch so poignantly that gooseflesh forms on my skin and tears come to my eyes in embarrassing profusion.

Robert J. McQueen, The Advocate

26 · gay · americans

A Film By Mariposa Film Group. Peter Adair. Nancy Adair. Veronica Selver. Robert Epstein. Andrew Brown. Lucy Massie Phenix. Distributed By Adair New Yorker Films. 16 West 61st Street, New York City 10023

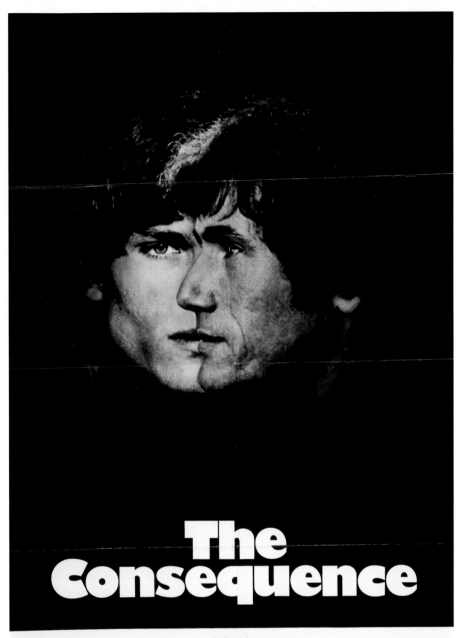

The Consequence

A film by
Wolfgang Petersen
Starring Jurgen Prochnow and Ernst Hannawald
a *Libra Films* release

WORD IS OUT (1978)
MARIPOSA FILM GROUP

This straightforward talking-heads documentary features interviews with twenty-six gay men and lesbians. Collectively produced by the Mariposa Film Group (which included such talented documentarians as Rob Epstein, Veronica Selver, Lucy Massie-Phoenix, and the late Peter Adair), *Word Is Out* pioneered the genre of gay documentary. The poster design reflects the simple but bold strategy of the film itself, putting proud gays and lesbians out in front of the camera to tell their stories.

THE CONSEQUENCE (*DIE KONSEQUENZ*) (1979)
LIBRA FILMS INTERNATIONAL

Jürgen Prochnow stars in this sensitive gay drama written and directed for German television by Wolfgang Petersen (*Das Boot, Air Force One*). Note the simple, yet ambiguous, eroticism of this U.S. one-sheet (from Libra Films International, best known for releasing David Lynch's *Eraserhead*).

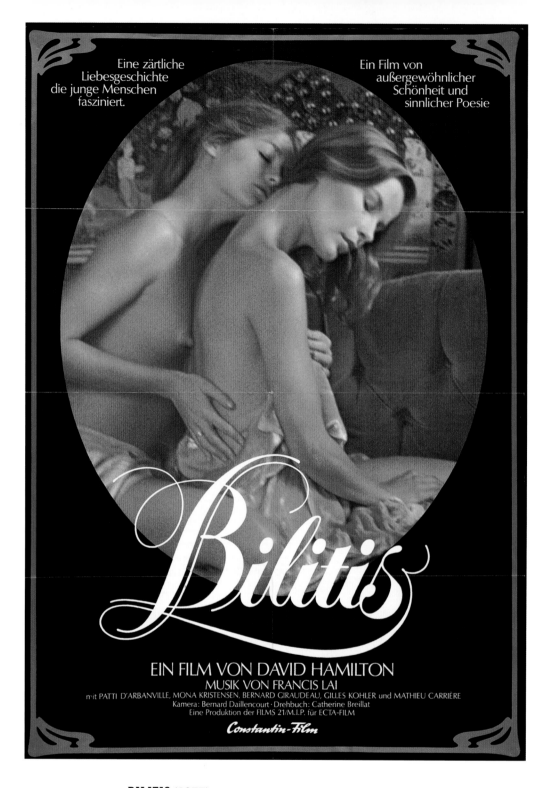

Eine zärtliche
Liebesgeschichte
die junge Menschen
fasziniert.

Ein Film von
außergewöhnlicher
Schönheit und
sinnlicher Poesie

Bilitis

EIN FILM VON DAVID HAMILTON
MUSIK VON FRANCIS LAI

mit PATTI D'ARBANVILLE, MONA KRISTENSEN, BERNARD GIRAUDEAU, GILLES KOHLER und MATHIEU CARRIÉRE
Kamera: Bernard Daillencourt · Drehbuch: Catherine Breillat
Eine Produktion der FILMS 21/M.I.P. für ECTA-FILM

Constantin-Film

BILITIS (1977)

CONSTANTIN FILM

British photographer David Hamilton, the quintessential purveyor of soft-focus prepubescent eroticism, made his first venture onto celluloid with this soft-core tale of "a young girl's sexual awakening." The U.S. one-sheet (not shown) takes the faux-lesbo approach, with a picture of the star (young Patti D'Arbanville) kissing herself in the mirror so that at first glance she appears to be kissing another girl. The tagline ("I don't even know how to kiss yet") reveals the illusion. The far more provocative poster for the film's German release is pictured here.

EARLY GAY PORN

For gay men coming of age and coming out in the late '60s and early '70s, often the first images they saw of men being intimate together were in gay pornography. Watching some of the early gay adult classics today, one can feel a visceral sense of pleasure and pride in the portrayals of men cruising, kissing, touching, embracing, and enjoying each other sexually. These films were much more than just one-handed amusements. The gay porn of the '60s and '70s served an important role in the shaping of gay identity and, ultimately, in the evolution of the gay rights movement.

The marketing materials for the gay porn of this era display an eagerness and naiveté reflective of the time. The genre evolved gradually over the years: it started with the posing-strap physique films of the '50s and '60s and moved on to the full-frontal nudity and soft-core films of the late '60s and eventually to the hard-core films of the '70s and beyond.

Most public exhibitions of these films happened at small gay cinemas and private clubs in larger cities (places such as the Park Theatre in Los Angeles and the Park-Miller and 55th Street Playhouse in New York City). The earliest ads appeared on flyers circulated at gay bars, in gay newspapers, and eventually even in the big dailies like the *New York Times* and *Los Angeles Times*.

The emergence of gay underground and gay independent film overlapped with the early days of gay porn. Many of the first gay-oriented movie theaters began by showing a combination of gay porn, gay underground films, and gay independent films; and some of the first gay indie films were made by gay porn directors such as Arthur Bressan, Pat Rocco, and Richard Fontaine. (For books that provide a more thorough overview of early gay porn production and exhibition, please see Jack Stevenson's *Fleshpot* and Kenneth Turan and Stephen Zito's *Sinema*.)

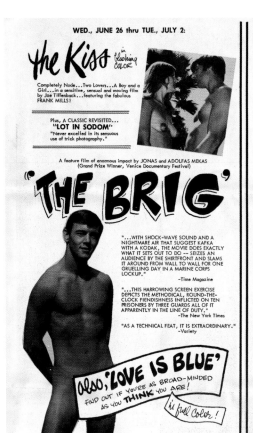

the Kiss *in flashing COLOR*

Completely Nude...Two Lovers...A Boy and a Girl...in a sensitive, sensual and moving film by Joe Tiffenback...featuring the fabulous FRANK MILLS!

Plus, A CLASSIC REVISITED...
"LOT IN SODOM"
"Never excelled in its sensuous use of trick photography."

A feature film of enormous impact by JONAS and ADOLFAS MEKAS
(Grand Prize Winner, Venice Documentary Festival)

"THE BRIG'

"...WITH SHOCK-WAVE SOUND AND A NIGHTMARE AIR THAT SUGGEST KAFKA WITH A KODAK, THE MOVIE DOES EXACTLY WHAT IT SETS OUT TO DO -- SEIZES AN AUDIENCE BY THE SHIRTFRONT AND SLAMS IT AROUND FROM WALL TO WALL FOR ONE GRUELLING DAY IN A MARINE CORPS LOCKUP."
—Time Magazine

"...THIS HARROWING SCREEN EXERCISE DEPICTS THE METHODICAL, ROUND-THE-CLOCK FIENDISHNESS INFLICTED ON TEN PRISONERS BY THREE GUARDS ALL OF IT APPARENTLY IN THE LINE OF DUTY."
—The New York Times

"AS A TECHNICAL FEAT, IT IS EXTRAORDINARY."
—Variety

also, 'LOVE IS BLUE'
FIND OUT IF YOU'RE AS BROAD-MINDED AS YOU **THINK** YOU ARE!
in full Color!

ANDY WARHOL'S "MY HUSTLER"
...Not recommended for your Aunt Fanny!

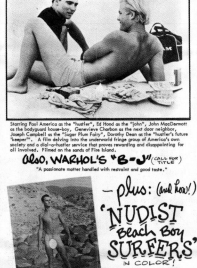

Starring Paul America as the "hustler", Ed Hood as the "john", John MacDermott as the bodyguard house-boy, Genevieve Charbon as the next door neighbor, Joseph Campbell as the "Sugar Plum Fairy", Dorothy Dean as the "hustler's future 'keeper'". A film delving into the underworld fringe group of America's own society and a dial-a-hustler service that proves rewarding and disappointing for all involved. Filmed on the sands of Fire Island.

also, WARHOL'S "B-J" (CALL FOR TITLE)
"A passionate matter handled with restraint and good taste."

– plus: (and how!)
'NUDIST Beach Boy SURFERS'
IN COLOR!
Extra: "F-F-F-T-C-M" ?

AT LAST... NOW YOU CAN SEE.
Jack Smith's Notorious
'Flaming Creatures'

"He has borne us a terrible beauty... at a time when terror and beauty are growing more and more apart, indeed are more and more denied. He has shocked us with the sting of mortal beauty. He has struck us with not the mere pity or curiosity of the perverse, but the glory, the pageantry of Transjvestia and the magic of Fairyland. He has lit up a part of life, although it is a part which most men scorn. No higher single praise can be given an artist than this, that he has expressed a fresh vision of life. We cannot wish more for Jack Smith than this: that he continues to expand that vision, and make it visible to us in flickering light and shadow, and in flame."
—Film Culture

also: Jerovi *in Color!*

a sexual probe of the Narcissus myth...
Jerovi Vaśĺ Sanson
"His beautiful male subject clothed at first in rich brocade, but later nude, is photographed lingering-ly in a lush garden. If sensual self-love in practice doesn't offend you, you'll find some vivid camera imagery."
—New York Post
"...I learned that certain films had not been admitted ...(one being) Jose Soltero's 'Jerovi', another film on masturbation like 'Ingram'. A part of the selection committee ran 'Jerovi' and they were visibly shaken."
—Notes from Ann Arbor Festival, by Gregory Markopoulos, The Village Voice.

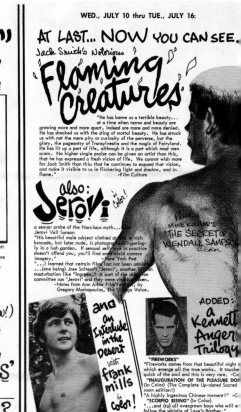

MIKE KUCHAR'S "THE SECRET OF WENDALL SAMPSON in Color!

and an Interlude in the Desert with frank mills in color!

ADDED: a Kenneth Anger Trilogy

"FIREWORKS"
"Fireworks comes from that beautiful night ... which emerge all the true works. It touches quick of the soul and this is very rare. —Co
"INAUGURATION OF THE PLEASURE DO (In Color) (The Complete Up-dated Sacred room edition!)
"A highly ingenious Chinese torment!" —Co
"SCORPIO RISING" (In Color)
"...and (to) all overgrown boys who will e follow the whistle of Love's Brother."
—From Kenneth Anger's Dedicati

A Most Unusual FILM FESTIVAL

--SUMMER, 1968--

Whereas:
the liberalization of sex laws throughout the world are opening the way to clearer and fuller understanding of all mankind, and

Whereas:
the importance of the motion picture and the motion picture maker to express honestly subjects of social concern has been recognized throughout the world, and

Whereas:
The First Ammendment of the United States Constitution provides:
Article I
"Congress shall make no law respecting an establishment of religion, or prohibiting the free exercise thereof; or abridging the freedom of speech or of the press; or the right of the people peaceably to assemble, and to petition the Government for a redress of grievances."

Therefore:
we the management of the Park Cinema, announce the very first assemblage of films of interest to the adult homosexual...as well as those interested in understanding homosexuality. Realizing fully that liberty is not license, we believe that at the root of all suppression of freedom of speech is a fear of unorthodoxy whether in religion, politics or sexual relations...a fear which has no excuse nor place in our free land. Freedom to think, to speak, to write and to film — and for the other person to listen and to see -- is essential to us as individuals and to the safety of our democratic society. Only in this way can a society grow from ignorance and irrationality to knowledge and reason, the firmest pillars of public morality.

PARK THEATRE PROGRAM (1968)

In June 1968, the first gay adult calendar at the Park (billed as "a most unusual film festival") included screenings of mostly gay underground films such as Jack Smith's *Flaming Creatures*, Warhol's *My Hustler*, and a Kenneth Anger trilogy. Mixed in with these were such soft-core shorts as *Nudist Beach Boy Surfers* and *Boys Out to Ball*. In these early days, the Park acquired films from small distributors and independent filmmakers such as Pat Rocco, Richard Fontaine, and Bob Mizer; the theater also held an annual amateur filmmakers contest. The Park was the first theater in Los Angeles to do regular, ongoing public exhibition of gay films (though in the late '50s, the Coronet catered to gay audiences and was busted for showing Kenneth Anger's homoerotic *Fireworks*).

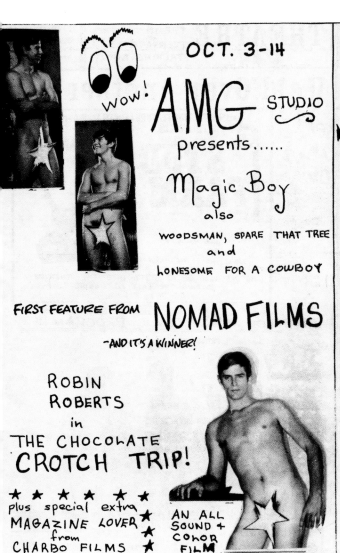

OCT. 3-14

Wow!

AMG STUDIO

presents......

Magic Boy

also

WOODSMAN, SPARE THAT TREE

and

LONESOME FOR A COWBOY

FIRST FEATURE FROM **NOMAD FILMS**

— AND IT'S A WINNER!

ROBIN ROBERTS in

THE CHOCOLATE CROTCH TRIP!

★ ★ ★ ★ ★

plus special extra ★

MAGAZINE LOVER ★

from ★

CHARBO FILMS ★

AN ALL SOUND + COLOR FILM

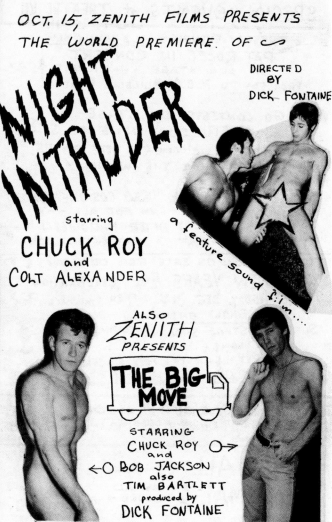

OCT. 15, ZENITH FILMS PRESENTS THE WORLD PREMIERE OF

NIGHT INTRUDER

DIRECTED BY DICK FONTAINE

a feature sound film....

starring

CHUCK ROY

and

COLT ALEXANDER

ALSO **ZENITH** PRESENTS

THE BIG MOVE

STARRING

CHUCK ROY and

BOB JACKSON

also

TIM BARTLETT

produced by

DICK FONTAINE

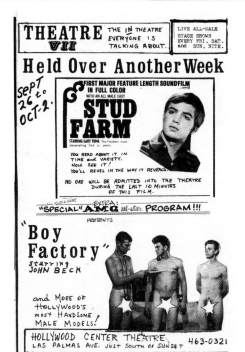

THEATRE VII

THE IN THEATRE EVERYONE IS TALKING ABOUT.

LIVE ALL-MALE STAGE SHOWS EVERY FRI. SAT. and SUN. NITE.

Held Over Another Week

SEPT 26 to OCT. 2.

FIRST MAJOR FEATURE LENGTH SOUNDFILM IN FULL COLOR WITH AN ALL MALE CAST

STUD FARM

STARRING GARY YUMA The freshest, most devastating find in years.

YOU READ ABOUT IT IN TIME and VARIETY.

NOW SEE IT!

YOU'LL REVEL IN THE WAY IT REVEALS.

NO ONE WILL BE ADMITTED INTO THE THEATRE DURING THE LAST 10 MINUTES OF THIS FILM.

IN COLOR "SPECIAL" **AMG** all-star PROGRAM!!!

PRESENTS

"Boy Factory"

STARRING JOHN BECK

and MORE OF HOLLYWOOD'S MOST HANDSOME MALE MODELS!

HOLLYWOOD CENTER THEATRE

LAS PALMAS AVE. JUST SOUTH OF SUNSET

463-0321

THEATRE VII PROGRAM (1969)

One of the early exhibitors of gay film in Los Angeles, Theatre VII (a private film club held at the Hollywood Center Theatre) presented a mix of stage shows and films. This handwritten flyer conveys a sense of where the gay porn "industry" was at in 1969. Note the attempt at Hollywood hyperbole in the *Stud Farm* ad as well as the cobilling of the AMG short *Boy Factory*.

MEN OF THE MIDWAY (1970)
ROD AND REEL FILMS

This is a classic all-male setting and a classic marketing approach, full of double entendres and out-of-control hyperbole.

BOYS IN THE SAND (1971)
POOLEMAR

This pioneering hard-core porno from Wakefield Poole was produced for $8,000 and went on to gross $400,000 when it played at the 55th Street Playhouse, New York City's biggest gay porn venue. Notable for legitimizing gay porn, Poole placed ads in, and got the film reviewed by, both the *New York Times* and *Variety*. *Boys in the Sand* stars Casey Donovan (a.k.a. Cal Culver), who quickly became the biggest name in gay porn. The original ad (designed by Ed Parente) features a wonderfully artsy, pointillist rendering of a hippie-ish clone with a beach ball. The title, of course, is a clever riff on the well-known Mart Crowley play/William Friedkin film *The Boys in the Band*.

THERE'S A SUCKER BORN EVERY MINUTE . . . AND THEY KNOW IT!

THE GREATEST ALL MALE FILM ON EARTH!

MEN OF THE MIDWAY

. . . WORKING HARD, PLAYING HARD, AND LOVING HARD

"MEN OF THE MIDWAY" A FILM BY ROGER EARL

STARRING TIM KRAMER • CHRIS BURNS
AND JACK STRIDER WITH BEAU MATTHEWS • JEFF POWE
FEATURING DUANE MACHULA • TOBY • BRUCE MCDONALD

SPECIAL GUEST STAR PAUL BARESSI AS DAD

FILMED IN EASTMAN COLOR • RATED X • ADULTS 18 AND OVER

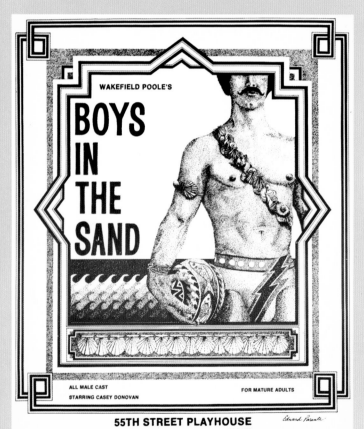

WAKEFIELD POOLE'S

BOYS IN THE SAND

ALL MALE CAST
STARRING CASEY DONOVAN

FOR MATURE ADULTS

Edward Parente

55TH STREET PLAYHOUSE
WEST 55TH (BETWEEN 6TH & 7TH) JU 6-4590

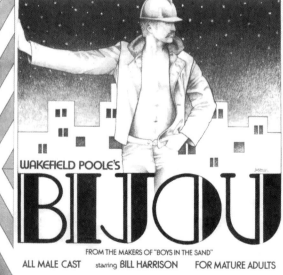

POOLEMAR PRODUCTIONS PRESENTS THE WORLD PREMIERE OF

WAKEFIELD POOLE'S

BIJOU

FROM THE MAKERS OF "BOYS IN THE SAND"
ALL MALE CAST starring BILL HARRISON FOR MATURE ADULTS

Produced by MARVIN SHULMAN

55TH STREET PLAYHOUSE BETWEEN 6TH & 7TH AVES.
JU 6-4590

WE SUGGEST YOU SEE IT FROM THE BEGINNING: 12:05; 1:30; 2:55; 4:20; 5:45; 7:10; 8:35; 10:00

BIJOU (1972)
POOLEMAR

Wakefield Poole's big-budget ($22,000) follow-up to *Boys in the Sand* is another gay porn classic. *Bijou* was named the best film of 1972 by (hetero) *Screw* magazine. Paul Jasmin's pencil drawing of the butch clone in the hard hat is a fabulous iconic image that perfectly evokes the era.

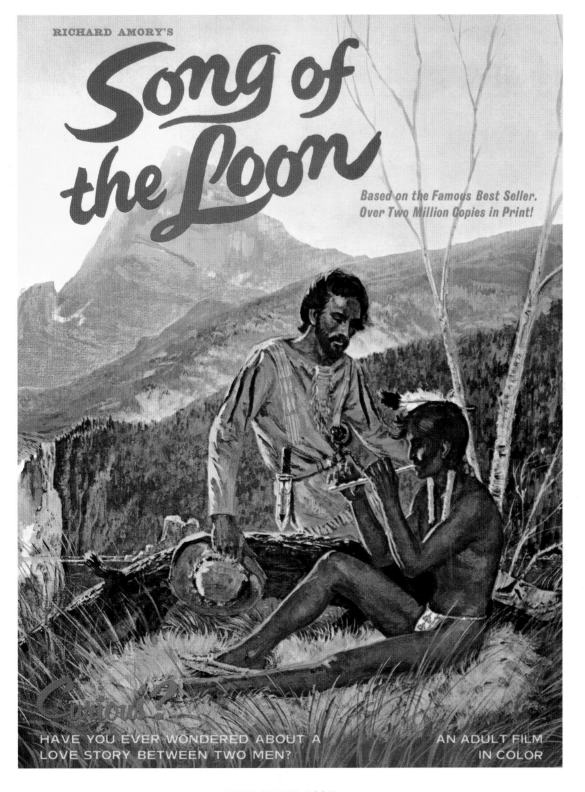

RICHARD AMORY'S

Song of the Loon

*Based on the Famous Best Seller.
Over Two Million Copies in Print!*

Curious?
HAVE YOU EVER WONDERED ABOUT A
LOVE STORY BETWEEN TWO MEN?

AN ADULT FILM
IN COLOR

SONG OF THE LOON (1970)

SAWYER PRODUCTIONS, LTD.

The first big-budget ($72,000) gay soft-core feature, *Song of the Loon* is an outdoorsy period-piece love story based on the top-selling gay erotic novel of the same name. The production notes go all out in presenting the film as a legitimate movie, even going so far as to thank "members of the U.S. Forestry Service for their cooperation and understanding during production." The image seen here is the cover of the press book.

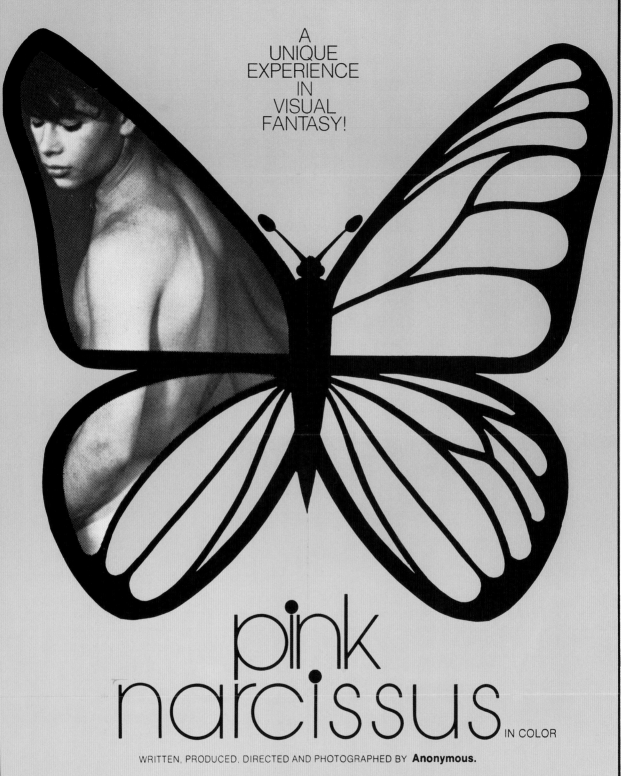

A
UNIQUE
EXPERIENCE
IN
VISUAL
FANTASY!

pink
narcissus IN COLOR

WRITTEN, PRODUCED, DIRECTED AND PHOTOGRAPHED BY **Anonymous.**

FOR ADULTS ONLY

A SHERPIX RELEASE

COMING SOON

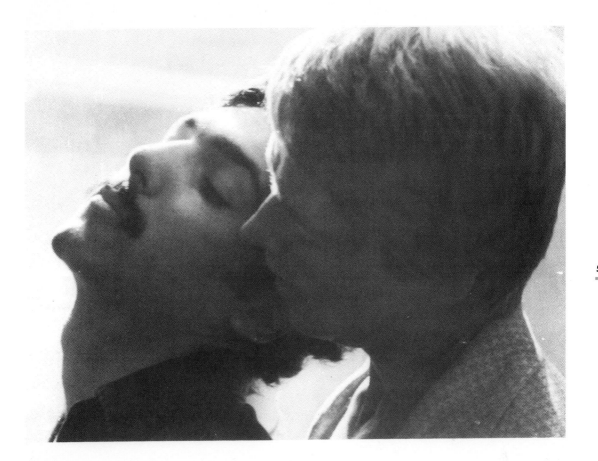

Peter de Rome's Tale of an American in Paris

Adam & Yves

A Hand in Hand Films Production

PINK NARCISSUS (1971)
SHERPIX

Shot on Super 8 and blown up to 35mm, this gorgeous Kodachrome soft-core porno was directed by Jim Bidgood (a.k.a. Anonymous) and features a wild array of fantasy sequences focusing on one young protagonist and involving a lot of great costumes.

ADAM & YVES (1974)
HAND-IN-HAND

This artsy hard-core feature was shot in France by director Peter de Rome and promoted with this wonderfully iconic image that conveys a bold gay sensuality in one simple shot.

SEX MAGIC (1977)

HAND-IN-HAND

Straight men are turned gay by a magic ring in this hard-core riff on Aladdin and the Magic Lamp, from director Jack Deveau. Very few of the ads from this era actually reveal any full-frontal nudity. Here's a rare exception.

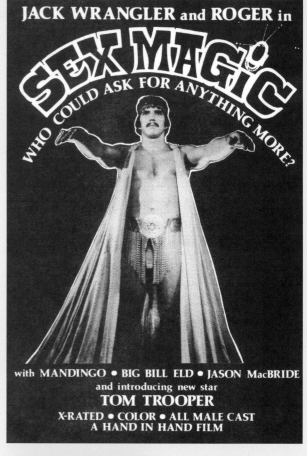

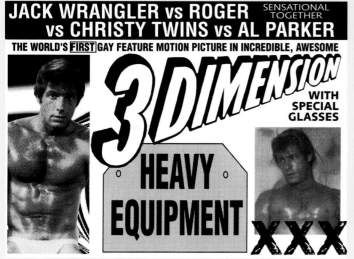

HEAVY EQUIPMENT (1977)

SIGNATURE FILMS/STRAND RELEASING

Heavy Equipment was the first gay hard-core feature shot in 3-D (followed by *Manhole*). Can't you just picture a theater full of horny gay men in red-and-blue cardboard glasses? Directed by Tom De Simone, the film is best remembered for its flying winged-dildo sequence. *Heavy Equipment* was briefly revived by Strand Releasing for film festival screenings in the late '90s.

STATION TO STATION (1974)

SIGNATURE FILMS/HAND-IN-HAND

Director Tom De Simone tried to inject a bit of substance into this film about a sixteen-year-old who gets in trouble with the police and has to deal with coming out to his family. It bombed at the box office. Whether this was attributable to the film itself or to the cheesy ad campaign is impossible to say.

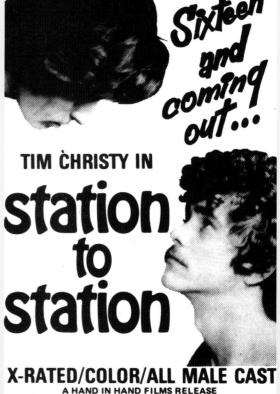

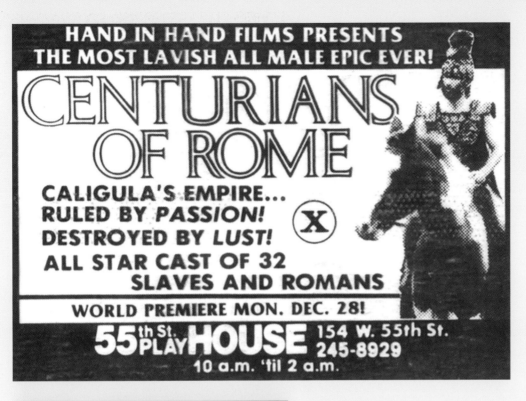

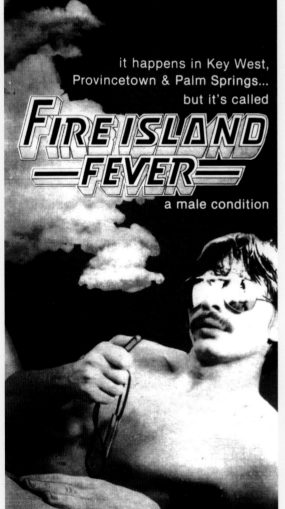

CENTURIANS OF ROME (1981)

HAND-IN-HAND

Unbelievably cheap and ridiculous advertising campaigns carry over into the early '80s in this ad for the release of John Christopher's (misspelled) *Centurians of Rome*. The filmmakers claimed to have spent nearly $100,000 on the production and said the money had come from a 1980 heist by a Brink's security guard.

FIRE ISLAND FEVER (1979)

HAND-IN-HAND

It took two years for Jack Deveau to get around to spoofing *Saturday Night Fever* (which was released in 1977). These days, gay porn spoofs often hit the streets even before the Hollywood films they're spoofing. Note the title treatment, which is a direct rip-off of the original *Saturday Night Fever* campaign.

BI

It should be noted that a majority of what we typically think of as gay or lesbian films would often be more accurately described as bisexual films, inasmuch as they portray characters who sleep with both men and women. Following are posters for some of the more notable releases that actually play up bisexuality as a thematic element. The '70s were a swinging decade indeed.

Conrad the butler.
If he doesn't kill you, he'll have an
affair with your wife. Or your son.
Or your daughter. If he doesn't commit
any of those delightful old
sins, he'll think of...
Something for Everyone.

The butler did it...to everyone!

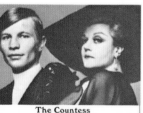
The Countess

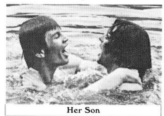
Her Son

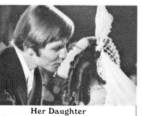
Her Daughter

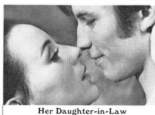
Her Daughter-in-Law

Angela Lansbury · Michael York
"Something for Everyone"
...a comedy of evil.

A CINEMA CENTER FILMS PRESENTATION

co-starring John Gill · Heidelinde Weis · Jane Carr · Eva Maria Meineke
introducing Anthony Corlan · screenplay by HUGH WHEELER · produced by JOHN FLAXMAN
from the novel "THE COOK" written by HARRY KRESSING · directed by HAROLD PRINCE · in COLOR
A MEDIA PRODUCTION · A NATIONAL GENERAL PICTURES RELEASE [R]

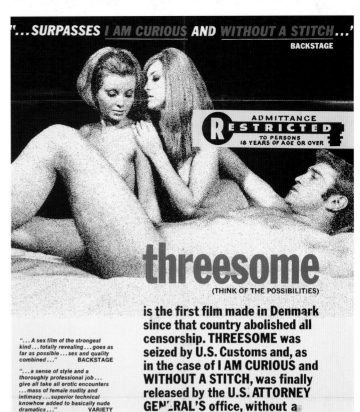

THREESOME (1970)

V.I. PRODUCTIONS, LTD.

Many soft-core films of the late '60s and early '70s compared themselves to the Swedish political docudrama *I Am Curious (Yellow)*, which was seized by U.S. Customs in 1968. The film (which includes full-frontal male nudity and simulated sex acts but is really an avant-garde reflection on Swedish politics) was finally released in American theaters and did a cool $20 million at the box office, thanks to all the controversy. The "possibilities" tagline concept gets taken up again on the U.S. one-sheet for the strictly hetero 1994 Stephen Baldwin/Lara Flynn Boyle/Josh Charles comedy that is also entitled *Threesome* ("One girl. Two guys. Three possibilities"). *Threesome* also happened to be the working title for Randall Kleiser's *Summer Lovers* (1982), which also fails to capitalize on its bisexual "possibilities."

SOMETHING FOR EVERYONE (1970)

NATIONAL GENERAL PICTURES

Michael York stars as the bisexual butler in this debut film from Broadway producer-director Harold Prince. While the print ad, pictured here, is explicit about the bisexual theme, all the poster designs utilize a completely different campaign meant to emphasize the dark-comedy aspect ("Compared to them, the Macbeths were just plain folks and the Borgias were a nice Italian family"). York also played bi two years later in Bob Fosse's *Cabaret* (1972).

A Joseph Janni production of John Schlesinger's Film

"Sunday Bloody Sunday"

starring
Glenda Jackson Peter Finch
Murray Head

with Peggy Ashcroft Tony Britton Maurice Denham Bessie Love Vivian Pickles Screenplay by Penelope Gilliatt
Produced by Joseph Janni Directed by John Schlesinger COLOR by DeLuxe® **R** RESTRICTED Under 17 requires accompanying Parent or Adult Guardian

United Artists
Entertainment from Transamerica Corporation

YOU'VE BEEN READING ABOUT THE CHIC BI-SEXUAL PHENOMENON

"Something for everybody." —Arthur Knight/PLAYGIRL MAGAZINE

"Swinging both ways is the new wrinkle explored by Metzger." Bruce Williamson/PLAYBOY

"Will appeal to just about any sexual appetite." —ADVOCATE

"Metzger explores a world of textures, sounds and colors, each complimenting the other, all part of the visual, aural, sexual experience...leaves everyone sexually charged." GALLERY MAGAZINE

"Radley Metzger has pulled a neat trick in making this well written, well photographed film a triple A—adult, amusing and artistic." Norma McLain Stoop/AFTER DARK

"Radley Metzger hilariously hits the bulls eye of Bi-sexual chic— a guaranteed turn on for any audience." Robert Weiner/INTERVIEW/ZOO WORLD

A Man and a Woman and a Woman and a Man and a Man and a Woman etc., etc.

NOW— FOR THE FIRST TIME SEE IT AT WORK AND PLAY IN RADLEY METZGER'S

"score"

With Claire Wilbur/Calvin Culver/Lynn Lowry/Gerald Grant/Carl Parker
Screenplay by Jerry Douglas/Eastmancolor/Directed by Radley Metzger
an Audubon Films Release/In Color

SUNDAY, BLOODY SUNDAY (1971)
UNITED ARTISTS

A straight woman and a gay man fall in love with a bisexual artist in this groundbreaking British drama, directed by John Schlesinger. The jumble of arms on the U.S. one-sheet has both more subtlety and more sensuality than the Australian daybill, which utilizes a large photo of Glenda Jackson and Peter Finch facing each other, with Murray Head between them in the background. Despite much critical acclaim and scads of Oscar nominations (for best actor, best actress, best director, and best original screenplay), *Sunday, Bloody Sunday* bombed at the U.S. box office.

SCORE (1973)
AUDUBON FILMS

Who's Afraid of Virginia Woolf? meets *The Boys in the Band* by way of a bad Euro sex film. A swinging couple (Jack and Elvira) try to seduce another couple (Betsy and Eddie). Jack tries to "score" with Eddie, Elvira with Betsy. Strangely, the tagline about a "Man and a Woman" and so on doesn't actually make the connection between a man and a man and a woman and a woman. Euro soft-core auteur Radley Metzger shot this bisexual swing-fest in Zagreb, Yugoslavia. *Score* is also notable for the appearance of Cal Culver (a.k.a. gay porn star Casey Donovan) as Eddie.

"The best romantic comedy pairing since Woody Allen met 'Annie Hall'!

Boy meets girl in 'A Different Story,' the difference being both are gay and both are played so engagingly by Perry King and Meg Foster."
— David Dugas, United Press International

PERRY KING · MEG FOSTER · "A DIFFERENT STORY"
also starring VALERIE CURTIN and PETER DONAT as "Sills"
Executive Producer MICHAEL F. LEONE · Produced by ALAN BELKIN · Directed by PAUL AARON
Written by HENRY OLEK · A Petersen Company Production

R RESTRICTED
UNDER 17 REQUIRES ACCOMPANYING
PARENT OR ADULT GUARDIAN

PRINTS BY CFI AVCO EMBASSY PICTURES Release © 1978 AVCO EMBASSY PICTURES CORP.

A DIFFERENT STORY (1978)
AVCO EMBASSY PICTURES

This is the kind of movie that will have you shaking your head, wondering how it ever got made. And talk about bad PR for gays and lesbians. Gay Perry King and lesbian Meg Foster get married to keep him from being deported, but then they fall in love and turn into heterosexuals. The hyperbolic and misguided one-sheet campaign goes so far as to compare the stars and the film to Gable and Colbert in *It Happened One Night*, Hepburn and Tracy in *Pat and Mike*, and George Segal and Glenda Jackson in *A Touch of Class*. Even the *New York Times* found the gays-turned-straight plot to be "insensitive and offensive."

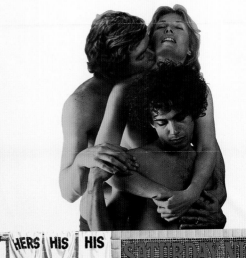

YOU MIGHT FORGIVE HIM IF HE WERE WITH ANOTHER WOMAN
COULD YOU GO ONE STEP FURTHER?

HERS HIS HIS SATURDAY NIGHT AT THE BATHS

FILMED ON LOCATION IN NEW YORK CITY AT THE WORLD FAMOUS CONTINENTAL BATHS

A BUCKLEY BROTHERS FILMS INC. PRESENTATION
STARRING ELLEN SHEPPARD ROBERT ABERDEEN DON SCOTTI With JANIE OLIVOR PHILLIP OWENS
STEVE OSTROW R. DOUGLAS BRAUTIGHAM PAUL J. OTT PAUL VANASE LAWRENCE SMITH
CALEB STONN as Judy Garland J.C. GAYNOR as SHIRLEY BASSEY Produced by DAVID BUCKLEY
and STEVE OSTROW Written by FRANKLIN KHEDOURI Directed by DAVID BUCKLEY R

SATURDAY NIGHT AT THE BATHS (1975)
BUCKLEY BROTHERS FILMS INC.

This early indie about a married man who gets seduced at the Continental Baths received mixed reviews from the gay community. The ad campaign, which describes the film as "a sympathetic, gutsy look at the defenses we erect against complete sexual expression," at least has its heart in the right place.

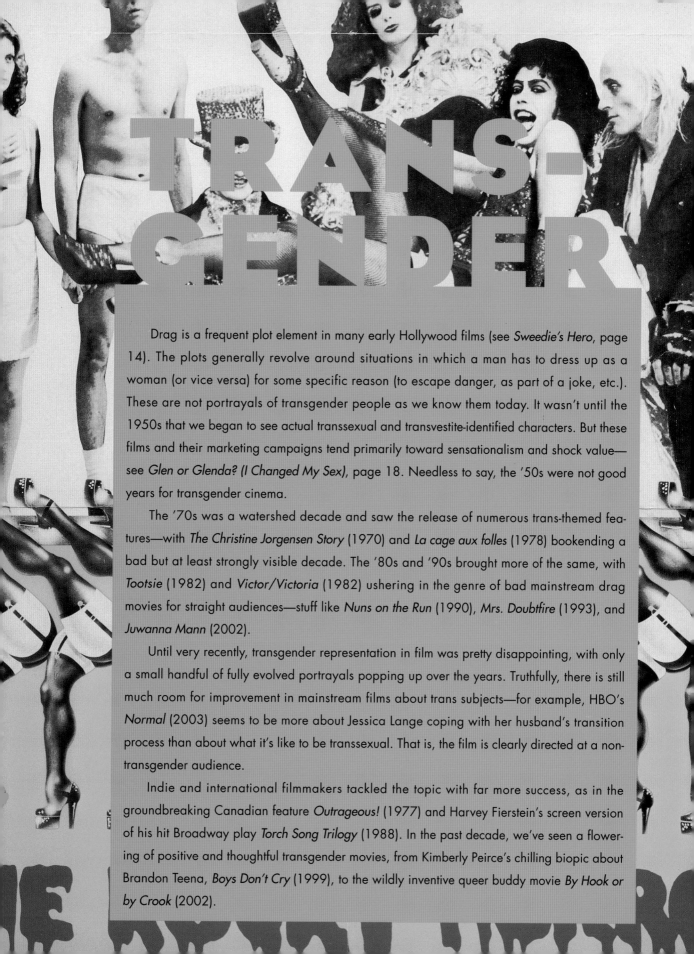

TRANS-GENDER

Drag is a frequent plot element in many early Hollywood films (see *Sweedie's Hero*, page 14). The plots generally revolve around situations in which a man has to dress up as a woman (or vice versa) for some specific reason (to escape danger, as part of a joke, etc.). These are not portrayals of transgender people as we know them today. It wasn't until the 1950s that we began to see actual transsexual and transvestite-identified characters. But these films and their marketing campaigns tend primarily toward sensationalism and shock value—see *Glen or Glenda? (I Changed My Sex)*, page 18. Needless to say, the '50s were not good years for transgender cinema.

The '70s was a watershed decade and saw the release of numerous trans-themed features—with *The Christine Jorgensen Story* (1970) and *La cage aux folles* (1978) bookending a bad but at least strongly visible decade. The '80s and '90s brought more of the same, with *Tootsie* (1982) and *Victor/Victoria* (1982) ushering in the genre of bad mainstream drag movies for straight audiences—stuff like *Nuns on the Run* (1990), *Mrs. Doubtfire* (1993), and *Juwanna Mann* (2002).

Until very recently, transgender representation in film was pretty disappointing, with only a small handful of fully evolved portrayals popping up over the years. Truthfully, there is still much room for improvement in mainstream films about trans subjects—for example, HBO's *Normal* (2003) seems to be more about Jessica Lange coping with her husband's transition process than about what it's like to be transsexual. That is, the film is clearly directed at a non-transgender audience.

Indie and international filmmakers tackled the topic with far more success, as in the groundbreaking Canadian feature *Outrageous!* (1977) and Harvey Fierstein's screen version of his hit Broadway play *Torch Song Trilogy* (1988). In the past decade, we've seen a flowering of positive and thoughtful transgender movies, from Kimberly Peirce's chilling biopic about Brandon Teena, *Boys Don't Cry* (1999), to the wildly inventive queer buddy movie *By Hook or by Crook* (2002).

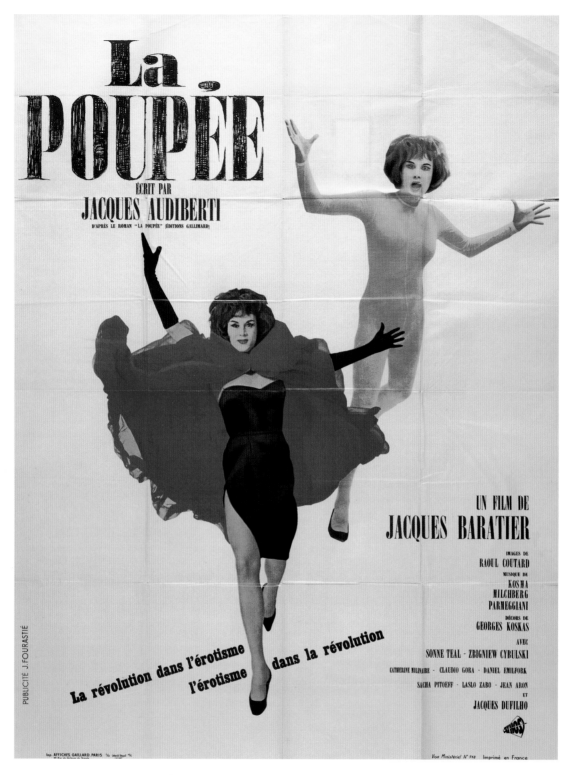

LA POUPÉE *(THE DOLL; HE, SHE OR IT)* **(1962)**
PROCINEX, PARIS/GASTON HAKIM INTERNATIONAL

In this obscure French-Italian farce, the famous female impersonator Sonne Teal stars as a professional drag artiste pretending to be a theater producer's wife. While the U.S. release title *(He, She or It)* was definitely on a par with *Glen or Glenda? (I Changed My Sex)*, the film is notable for cinema's first starring role for a real-life female impersonator since the 1920s, when vaudeville star Julian Eltinge starred in a long run of successful silent comedies. The tagline reads: "Revolution in eroticism. Eroticism in revolution."

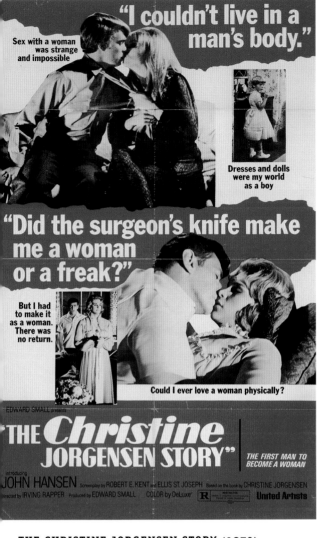

THE CHRISTINE JORGENSEN STORY (1970)
UNITED ARTISTS

Again, pretty much on a par with *Glen or Glenda?* in its marketing strategy, but at least we have an attempt at a sympathetic transsexual portrayal (badly acted by John Hansen, but cowritten by Jorgensen and based on her autobiography). The first-person quotes make the one-sheet look like a *National Enquirer* cover story.

I WANT WHAT I WANT (1972)
CINERAMA

This sympathetic, if limited, transsexual melodrama stars a biological woman (Anne Heywood) in the role of "Roy/Wendy." The cheesy artistic rendering of Roy gazing longingly at the reflection of Wendy conveys the weird feel of the film quite well—like a queer pulp novel come to life. Note the use of the word *sensational* as well as the first-person transsexual statement in place of a tagline, in the same style as that used for *The Christine Jorgensen Story.*

THE ROCKY HORROR PICTURE SHOW (1976)
20TH CENTURY FOX

The tone of the campaign for *Rocky Horror* sums things up pretty well in terms of main-stream cinema's attitude toward trans characters. The contempt and bemusement once reserved for homosexuals are now visited on cross-dressers and transsexuals as the poster mocks the idea of a transvestite hero. 20th Century Fox chickened out on giving the film a proper theatrical release, but our hero, Frank N. Furter (the Sweet Transvestite from Transsexual, Transylvania), had the last laugh as *Rocky Horror* went on to become the most successful midnight movie of all time.

A STRANGE ROLE (HERKULESFÜRDÖI EMLEK) (1976)
PIKE FILMS

A World War I soldier masquerades as a female nurse. Hungarian writer-director Pál Sándor's cross-dressing drama took home numerous awards at the 1977 Berlin International Film Festival. Eastern European poster design has long been acclaimed as some of the best in the world. This one is no exception.

A STRANGE ROLE

It is 1919.
An Empire
is crumbling...
A young man is
running for his life...
disguised as a woman.

AN EXPLORATION OF THE
MALE/FEMALE PSYCHE

Milly always wondered what it was like to be a boy.

This morning she woke up with her first clue.

The comedy switch of the year.

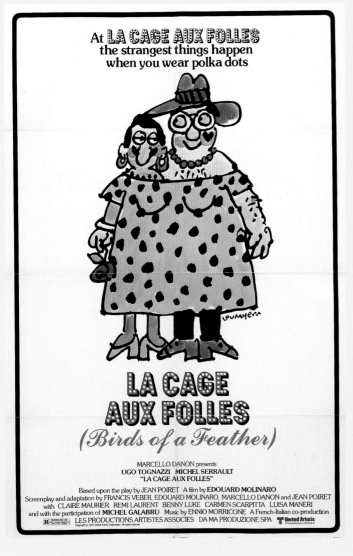

At LA CAGE AUX FOLLES the strangest things happen when you wear polka dots

LA CAGE AUX FOLLES
(Birds of a Feather)

MARCELLO DANON presents
UGO TOGNAZZI MICHEL SERRAULT
"LA CAGE AUX FOLLES"
Based upon the play by JEAN POIRET A film by EDOUARD MOLINARO
Screenplay and adaptation by FRANCIS VEBER, EDOUARD MOLINARO, MARCELLO DANON and JEAN POIRET
with CLAIRE MAURIER REMI LAURENT BENNY LUKE CARMEN SCARPITTA LUISA MANERI
and with the participation of MICHEL GALABRU Music by ENNIO MORRICONE A French-Italian co-production
R LES PRODUCTIONS ARTISTES ASSOCIES DA MA PRODUZIONE SPA United Artists
A Transamerica Company

SOMETHING SPECIAL (1986)
CINEMA GROUP

This unbelievably entertaining female-to-male teen comedy wa released theatrically in 1986 and quickly disappeared from view. Thoug the ending is a disappointment, *Something Special* is well worth trackin down (it is available on video), given that it's one of very few films to pl out the fantasy of a girl who wants to be a boy. The cartoon promo a reflects the film's lightweight, *Afterschool Special* tone.

LA CAGE AUX FOLLES (1978)
UNITED ARTISTS

The poster for this huge art-house hit accurately conveys the film's sense of wackiness and cheap humor. The rendering of bad drag on a hairy guy and the polka-dot dress quip reflect the tone of the times—transvestites are laughable (though if memory serves, there is no polka-dot dress in the film itself). While Albin, the film's transvestite character, has aspects of dignity and is ultimately triumphant, he exists in the film primarily as an object of scorn and disdain—much to the amusement of gay and straight audiences everywhere (*La cage* took in $20 million at the U.S. box office).

KISS OF THE SPIDER WOMAN (1984)
ISLAND ALIVE

Gay audiences were all really excited when William Hurt, wh played Molina, became the first actor portraying a gay/transgender cha acter to bring home a Best Actor Oscar—but it was unfortunate that Moli had to be such a pathetic, self-sacrificing figure. The one-sheet is fabulou even though it gives no indication of the film's gay content. This may help explain the film's popularity at the box office. Other U.S. one-sheet style feature the eerie, cartoonlike image of the Spider Woman. The Japane poster goes all out with a large color photo of Hurt in bright-red lipsti seated in front of his makeup mirror.

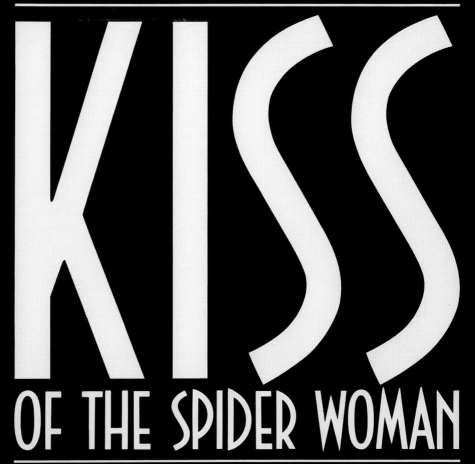

WILLIAM **HURT** | RAUL **JULIA** | SONIA **BRAGA**

KISS

OF THE SPIDER WOMAN

BASED ON THE NOVEL BY
MANUEL
PUIG

WRITTEN BY
LEONARD
SCHRADER

ISLAND ALIVE
RELEASING

PRODUCED BY
DAVID
WEISMAN

DIRECTED BY
HECTOR
BABENCO

Vera

From the New Brazilian Cinema

THE STORY OF A WOMAN LONGING TO BE A MAN

A FILM BY SERGIO TOLEDO STARRING ANA BEATRIZ NOGUEIRA AN EMBRAFILME PRODUCTION

JERRY WINTERS AND GRANGE COMMUNICATIONS PRESENT A KINO INTERNATIONAL RELEASE

Vera

From the New Brazilian Cinema

THE STORY OF A WOMAN
LONGING TO BE A MAN

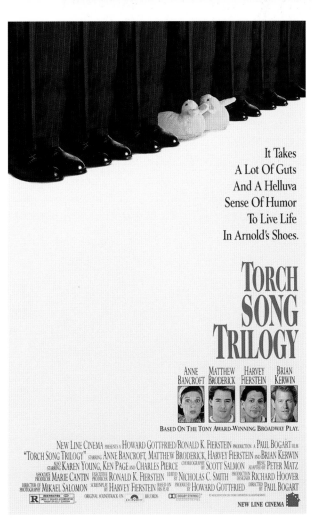

It Takes
A Lot Of Guts
And A Helluva
Sense Of Humor
To Live Life
In Arnold's Shoes.

TORCH SONG TRILOGY (1988)
NEW LINE CINEMA

Harvey Fierstein's self-empowering tale of the life and loves of a drag queen was certainly the most widely released "positive" queer film of the '80s. New Line Cinema booked *Torch Song* into the Cineplex-Odeon theater chain, which meant it played multiplexes (not just small art houses) all across the country. As with most mainstream releases with queer themes as their primary subject matter, the publicity campaign downplayed the gayness of the film, presumably in an attempt to appeal to a wider (heterosexual) audience by identifying the concerns of the film as "universal." The voiceover of the film's trailer cheerfully tells us: "It's not just about some people; it's about everyone." Roger Ebert took the special logic of the marketing campaign to heart when he reviewed *Torch Song Trilogy* (which began as a stage production) on *Siskel and Ebert at the Movies*. Ebert explained to Gene Siskel, "It's not a gay play anyway; it's about people who love each other who happen to be men." The poster campaign for *Torch Song* actually strikes a pretty good, if somewhat assimilationist, tone. The one-sheet (not shown) pictures Arnold surrounded by his mom and two boyfriends, with the tagline, "All Arnold wants out of life is an apartment he can afford, a job he actually likes and a relationship that works. Of course, a little luck couldn't hurt either." The smaller poster, pictured here, works a more goofy angle (like *La cage aux folles*), first evoking the idea that Arnold's effeminacy is funny, but then undercutting that with the tagline, which points to his "guts" and the idea that it's not easy being queer.

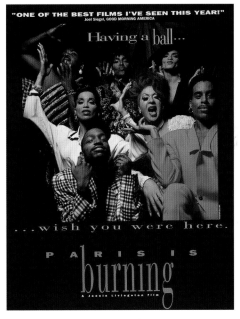

VERA (1986)
KINO INTERNATIONAL

This groundbreaking Brazilian drama marks the first appearance of a female-to-male transsexual character in a feature film. Ana Beatriz Nogueira won the Best Actress award at the 1987 Berlin Film Festival for her portrayal of Vera/Bauer, who grows up in an orphanage and comes to believe that she is a man in a woman's body. Vera/Bauer and new girlfriend, Clara (Aida Leiner), grapple with Vera's gender dysphoria, and an ambiguous ending (open to two very different interpretations) posits a disturbing fate for Bauer. The use of the mirrored male/female silhouette in the U.S. one-sheet is a bit reductive (and the female figure is actually an image of Clara), but, as B. Ruby Rich said in her original *Village Voice* review, "*Vera* is one of the most intriguing portraits of gender construction—and deconstruction—yet seen on the screen."

PARIS IS BURNING (1991)
MIRAMAX PRESTIGE

Jennie Livingston's groundbreaking exploration of the Harlem House Ball circuit was released theatrically by Miramax in August 1991 after scooping up awards at major film festivals from Sundance to Berlin. *Paris Is Burning* went on to break box-office records at New York City's Film Forum, where it screened for twenty-three weeks. The celebratory tone of this group shot conveys the dynamic energy of the film and its charismatic subjects (whose real lives were far from the apparent glamour portrayed in the poster).

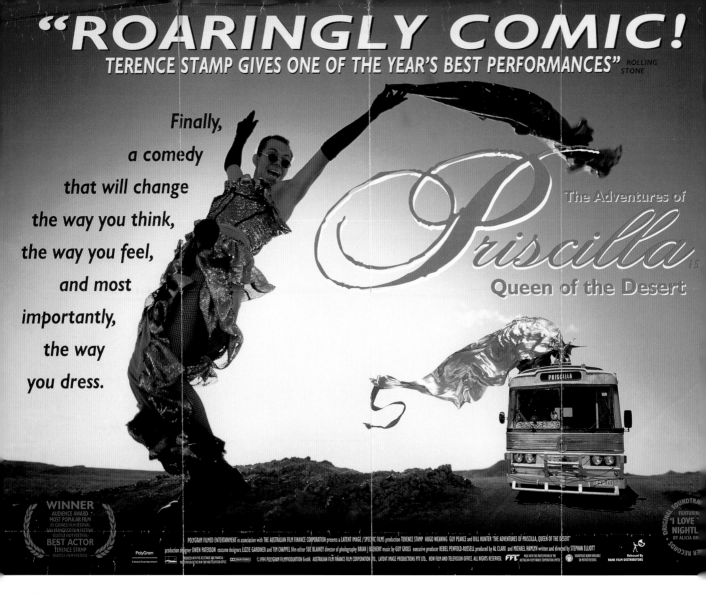

THE ADVENTURES OF PRISCILLA, QUEEN OF THE DESERT (1994)

POLYGRAM FILMED ENTERTAINMENT/RANK FILM DISTRIBUTORS

The U.S. one-sheet for this fabulously colorful film consists simply of the silhouettes of the drag queens against a brown background. This British quad conveys the celebratory tone and sassy attitude of the film much more effectively via its use of color and dynamic imagery, and a lovely shot of Hugo Weaving (pre–*Lord of the Rings* and *The Matrix*).

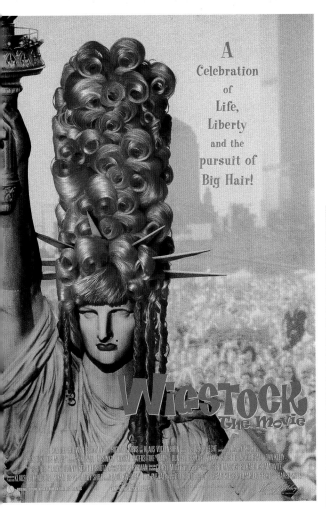

WIGSTOCK (1995)

SAMUEL GOLDWYN COMPANY

This concert film documentary about the annual Wigstock festival in New York City did poorly at the box office, even as it showcased performances by the best-known drag queens of the time (Lady Bunny, RuPaul, Lypsinka, and others).

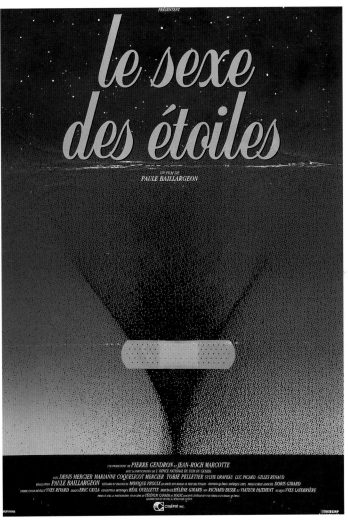

SEX OF THE STARS *(LE SEXE DES ÉTOILES)* (1993)

NATIONAL FILM BOARD OF CANADA

The extremely unfortunate poster design for this well-intentioned Canadian drama comes off as a sophomoric joke. *Sex of the Stars* does try to draw a positive portrait of its transsexual protagonist but is ultimately unsuccessful, in part because the film is so obviously trying to appeal to a mainstream/nonqueer audience. Along the lines of William Hurt's Molina, Denis Mercier's Marie-Pierre (formerly Pierre) is ultimately too pathetic a figure (coincidentally, Mercier took home a Canadian Best Actor Genie for the role).

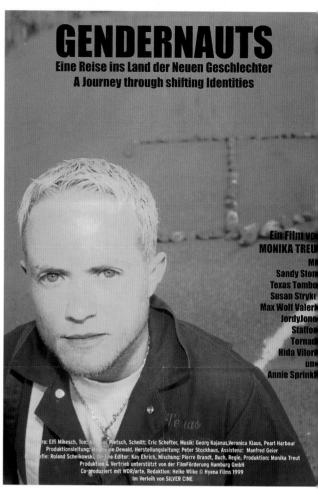

THE BIRDCAGE (1996)
UNITED ARTISTS

The "Come as you are" tagline strikes a nice liberating tone for the top-grossing gay-themed film of all time (*The Birdcage* took in $124 million at the U.S. box office).

GENDERNAUTS (1999)
FIRST RUN FEATURES

Monika Treut's documentary about transgender identities offers a series of profiles of individual trans people who talk about their lives and gender philosophies. The German/U.S. poster, with blue-eyed dreamboat Texas Tomboy gazing out at the viewer, conveys a wonderful sense of strong and self-determined trans identity, in stark contrast to the pathologized trannies on view for hetero amusement in the early '70s.

BOYS DON'T CRY (1999)
FOX SEARCHLIGHT

Fox Searchlight put a remarkable amount of integrity into the marketing campaign for *Boys Don't Cry*, a small indie about an unlikely, tragic transgender hero. This little movie that had the courage to be itself snagged the 1999 Best Actress Oscar for star Hilary Swank. It is interesting to note that two of the three queer characters to nab best-acting Oscars were transgender portrayals (William Hurt as Molina in *Kiss of the Spider Woman* and Swank in this film; the other was Tom Hanks in *Philadelphia*).

1999 OFFICIAL SELECTION
NEW YORK FILM FESTIVAL

1999 OFFICIAL SELECTION
WORLD CINEMA
TORONTO FILM FESTIVAL

1999 OFFICIAL SELECTION
CINEMA OF THE PRESENT
VENICE FILM FESTIVAL

A TRUE STORY

ABOUT FINDING

THE COURAGE

TO BE YOURSELF.

HILARY SWANK
CHLOË SEVIGNY
PETER SARSGAARD

BOYs
DOn'T
CRy

FOX SEARCHLIGHT PICTURES AND THE INDEPENDENT FILM CHANNEL PRODUCTIONS PRESENT
A KILLER FILMS/HART·SHARP ENTERTAINMENT PRODUCTION A KIMBERLY PEIRCE FILM "BOYS DON'T CRY"
HILARY SWANK CHLOË SEVIGNY PETER SARSGAARD BRENDON SEXTON III ALISON FOLLAND
ALICIA GORANSON MATT McGRATH ROB CAMPBELL AND JEANNETTA ARNETTE AS LANA'S MOM
CASTING BY HOPKINS·SMITH, AND BARDEN MUSIC BY NATHAN LARSON MUSIC SUPERVISOR RANDALL POSTER EDITOR LEE PERCY A.C.E.
PRODUCTION DESIGNER MICHAEL SHAW CINEMATOGRAPHER JIM DENAULT PRODUCER BRADFORD SIMPSON
EXECUTIVE PRODUCERS PAMELA KOFFLER, JONATHAN SEHRING, CAROLINE KAPLAN, JOHN SLOSS
PRODUCED BY JEFFREY SHARP, JOHN HART, EVA KOLODNER, CHRISTINE VACHON
WRITTEN BY KIMBERLY PEIRCE, ANDY BIENEN DIRECTED BY KIMBERLY PEIRCE

www.boysdontcry.com

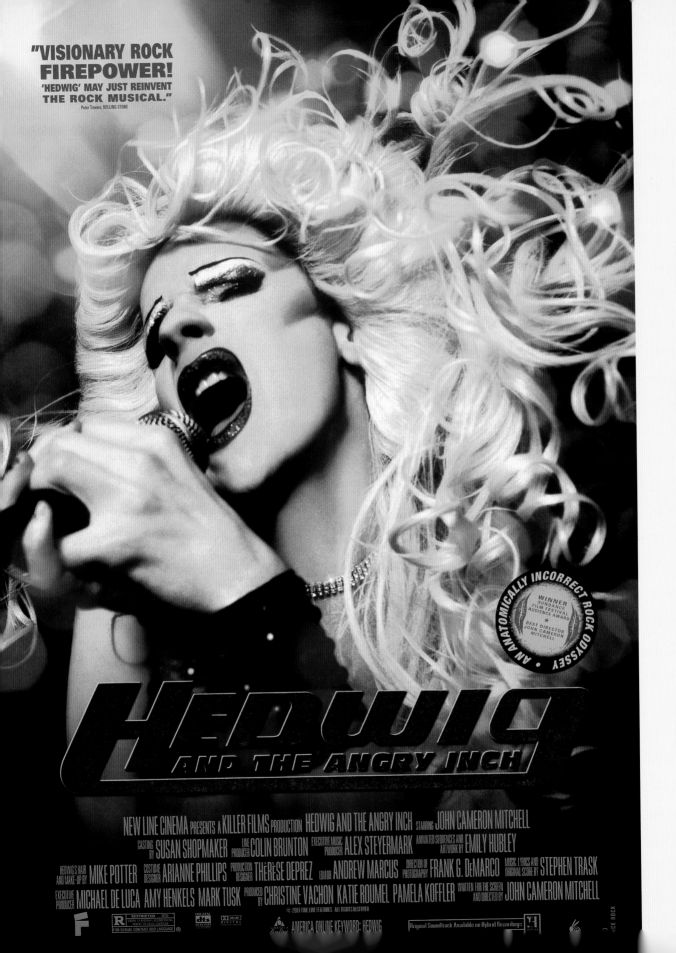

"VISIONARY ROCK
FIREPOWER!
'HEDWIG' MAY JUST REINVENT
THE ROCK MUSICAL."
Peter Travers, ROLLING STONE

AN ANATOMICALLY INCORRECT ROCK ODYSSEY •

WINNER
SUNDANCE
FILM FESTIVAL
AUDIENCE AWARD
★
BEST DIRECTOR
JOHN CAMERON
MITCHELL

HEDWIG
AND THE ANGRY INCH

NEW LINE CINEMA PRESENTS A KILLER FILMS PRODUCTION HEDWIG AND THE ANGRY INCH STARRING JOHN CAMERON MITCHELL

CASTING BY SUSAN SHOPMAKER LINE PRODUCER COLIN BRUNTON EXECUTIVE MUSIC PRODUCER ALEX STEYERMARK ANIMATED SEQUENCES AND ARTWORK BY EMILY HUBLEY

HEDWIG'S HAIR AND MAKE-UP BY MIKE POTTER COSTUME DESIGNER ARIANNE PHILLIPS PRODUCTION DESIGNER THÉRÈSE DEPREZ EDITOR ANDREW MARCUS DIRECTOR OF PHOTOGRAPHY FRANK G. DeMARCO MUSIC, LYRICS AND ORIGINAL SCORE BY STEPHEN TRASK

EXECUTIVE PRODUCER MICHAEL DE LUCA AMY HENKELS MARK TUSK PRODUCED BY CHRISTINE VACHON KATIE ROUMEL PAMELA KOFFLER WRITTEN FOR THE SCREEN AND DIRECTED BY JOHN CAMERON MITCHELL

RESTRICTED
R UNDER 17 REQUIRES ACCOMPANYING PARENT OR ADULT GUARDIAN
FOR SEXUAL CONTENT AND LANGUAGE

DIGITAL dts DOLBY DIGITAL

AMERICA ONLINE KEYWORD: HEDWIG

Original Soundtrack Available on Hybrid Recordings

ICK ROCK

PRINCESA (2001)
STRAND RELEASING

In *Princesa*, nineteen-year-old Ingrid de Souza, a transsexual who is not a professional actress, gives a powerful performance as Fernanda/o, a Brazilian prostitute trying to save enough money for her sex-change operation. The bold U.S. one-sheet presents a straight-forward (and very sexy) image of the transsexual star.

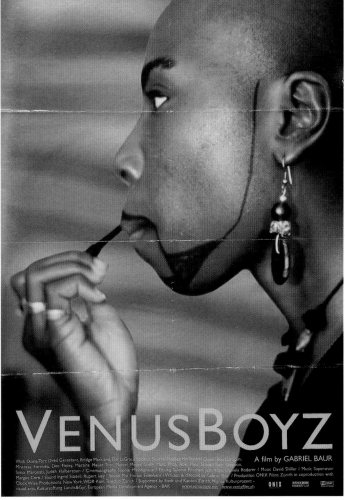

HEDWIG AND THE ANGRY INCH (2001)
FINE LINE FEATURES

This fabulous marketing campaign had the crossover appeal to bring in straight audiences for John Cameron Mitchell's filmed version of his wildly successful Off-Broadway play about an East German rock star who is the victim of a botched sex-change operation.

VENUS BOYZ (2001)
XENIX FILM/FIRST RUN FEATURES

Director Gabriel Baur brings together a series of portraits of New York and London drag kings—including Del LaGrace Volcano, Mo B. Dick, Diane Torr, and Dréd Gerestant (the gorgeous guy on this British poster)—in this nicely shot, but dreadfully dull, documentary.

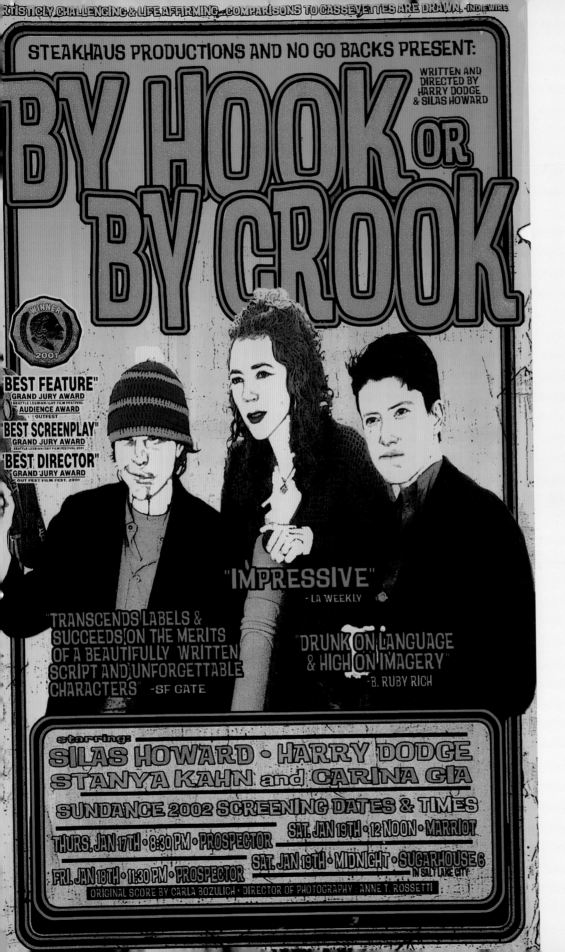

ARTISTICLY CHALLENGING & LIFE AFFIRMING - COMPARISONS TO CASSEVETTES ARE DRAWN. -INDIEWIRE

STEAKHAUS PRODUCTIONS AND NO GO BACKS PRESENT:

BY HOOK OR BY CROOK

WRITTEN AND DIRECTED BY HARRY DODGE & SILAS HOWARD

WINNER 2001

"BEST FEATURE"
GRAND JURY AWARD
SEATTLE LESBIAN/GAY FILM FESTIVAL
AUDIENCE AWARD
OUTFEST

"BEST SCREENPLAY"
GRAND JURY AWARD
SEATTLE LESBIAN/GAY FILM FESTIVAL 2001

"BEST DIRECTOR"
GRAND JURY AWARD
OUT FEST FILM FEST. 2001

"IMPRESSIVE"
- LA WEEKLY

"TRANSCENDS LABELS &
SUCCEEDS ON THE MERITS
OF A BEAUTIFULLY WRITTEN
SCRIPT AND UNFORGETTABLE
CHARACTERS" -SF GATE

"DRUNK ON LANGUAGE
& HIGH ON IMAGERY"
-B. RUBY RICH

starring:
SILAS HOWARD · HARRY DODGE
STANYA KAHN and CARINA GIA

SUNDANCE 2002 SCREENING DATES & TIMES

THURS. JAN 17TH · 8:30 PM · PROSPECTOR

SAT. JAN 19TH · 12 NOON · MARRIOT

FRI. JAN 18TH · 11:30 PM · PROSPECTOR

SAT. JAN 19TH · MIDNIGHT · SUGARHOUSE 6
IN SALT LAKE CITY

ORIGINAL SCORE BY CARLA BOZULICH · DIRECTOR OF PHOTOGRAPHY : ANNE T. ROSSETTI

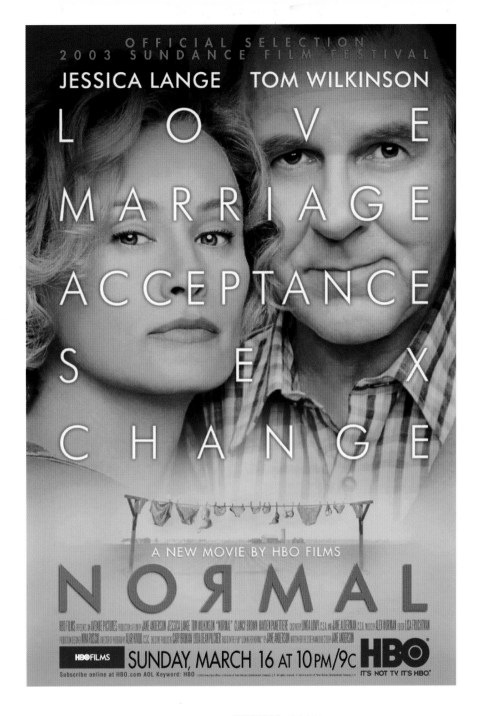

OFFICIAL SELECTION
2003 SUNDANCE FILM FESTIVAL

JESSICA LANGE TOM WILKINSON

L O V E
MARRIAGE
ACCEPTANCE
S E X
CHANGE

A NEW MOVIE BY HBO FILMS

NORMAL

SUNDAY, MARCH 16 AT 10PM/9C HBO
Subscribe online at HBO.com AOL Keyword: HBO IT'S NOT TV. IT'S HBO®

NORMAL (2003)
HBO FILMS

Seemingly an indicator of significant progress in trans visibility and mainstream acceptance, HBO's *Normal* was preceded by an advertising blitz that prepared us for the worst. In the poster's sensational all-caps punchline ("SEX CHANGE"), *Normal* envisions a hetero and gender-normative audience from the get-go. Certainly the film's earnest pathos and attempts at humor are preferable to the tranny biopics of the '70s, but at this point in time, it's reasonable to expect a bit more sophistication and complexity alongside the empathetic plea for tolerance. (Describing the film as dated and simplistic, the *New York Times* went so far as to draw parallels between *Normal* and *Glen or Glenda?*.)

BY HOOK OR BY CROOK (2002)
NGB PRODUCTIONS/STEAKHAUS PRODUCTIONS

Designed by rock-poster artiste Ron Donovan, this special-edition silk-screened poster (for the film's Sundance Film Festival presentation) incorporates metallic glitter layered over striking colors. It conveys the colorful, energetic tone of the groundbreaking butch buddy movie, written, directed, and produced by and starring Harriet "Harry" Dodge and Silas Howard.

CHAPTER IV the '80s

The steady stream of negative Hollywood portrayals proved eventually to be a significant catalyst in the development of political consciousness for gay people, and other underrepresented groups, whose sense of community and shared identity was galvanized in the struggle against Hollywood's continuing misrepresentation of their lives. The most significant confrontation between the gay community and the film industry came with the 1979 production and subsequent 1980 release of William Friedkin's *Cruising*. Gay activists picketed the film while it was being made and on its release—taking Hollywood and the film industry to task for decades of negative and dismissive on-screen portrayals of GLBT characters. The film—a violent drama about an ostensibly straight cop, played by Al Pacino, going undercover to catch a serial killer on the loose in New York City's gay leather scene—carried on the venerable Hollywood trope of the homosexual as a psychotic figure prone to violence (whether as murderer, murder victim, or suicide).

A small burst of Hollywood gay films in the early '80s showed some promise, followed by a burst of superior indies in 1986 that was dubbed the Gay New Wave. The decade ended on a high note when openly gay playwright Harvey Fierstein adapted his Broadway smash *Torch Song Trilogy* (page 73) for the big screen and introduced middle America to a talented, lovable, self-respecting, Jewish drag queen named Arnold.

Al Pacino is Cruising for a killer.

AL PACINO
CRUISING

LORIMAR PRESENTS A JERRY WEINTRAUB PRODUCTION
AL PACINO
WILLIAM FRIEDKIN'S 'CRUISING'
PAUL SORVINO

KAREN ALLEN PRODUCED BY JERRY WEINTRAUB WRITTEN FOR THE SCREEN AND DIRECTED BY WILLIAM FRIEDKIN
BASED UPON THE NOVEL BY GERALD WALKER MUSIC—JACK NITZSCHE TECHNICOLOR®

Released thru
United Artists

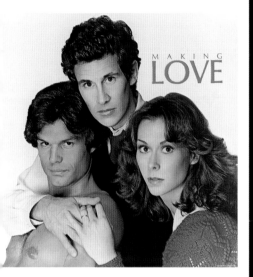

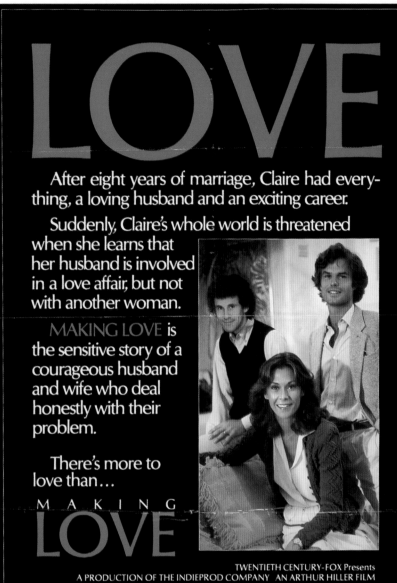

MAKING LOVE (1982)
20TH CENTURY FOX

The trailer for this soapy gay melodrama from openly gay screenwriter Barry Sandler touts *Making Love* as "a love story for the '80s." As the trailer's syrupy voiceover goes on, adjectives such as *bold* and *compassionate* replace such previously overused descriptors as *shocking* and *perverse*. Here, rather than titillating the audience with the suggestion of smut, Hollywood pats itself on the back for its "courage" in treating such important subject matter. The extremely texty one-sheet shows the same overly serious approach, while the special square poster (designed for posting at gay bars) gives the gay boys what they want (Harry Hamlin's shiny nipples).

CRUISING (1980)
UNITED ARTISTS

This predominantly black (and fairly boring) poster design is an appropriate companion piece to the equally dark *Windows* poster design on page 92. This pair of queer psycho-killer dramas came out at the beginning of 1980 (*Windows* in January, *Cruising* in February), unleashing an overdue storm of protest from the gay community.

BRAD DAVIS – FRANCO NERO

QUERELLE

un film de R.W. FASSBINDER
d'après QUERELLE DE BREST de JEAN GENET

avec
JEANNE MOREAU
LAURENT MALET

et avec HANNO POSCHL - GUNTHER KAUFMANN - BURKHARD DRIEST - DIETER SCHIDOR - ROGER FRITZ
NADJA BRUNKHORST sur des photos de ROGER FRITZ - MICHAEL McLERNON - NEIL BELL - KARL SCHEYDT

chef opérateur XAVER SCHWARZENBERGER - décorateur ROLF ZEHETBAUER - costumier BARBARA BAUM
musique PEER RABEN - un film produit par DIETER SCHIDOR
scénario RAINER WERNER FASSBINDER - son VLADIMIR VIZNER - montage JULIANE LORENZ

G

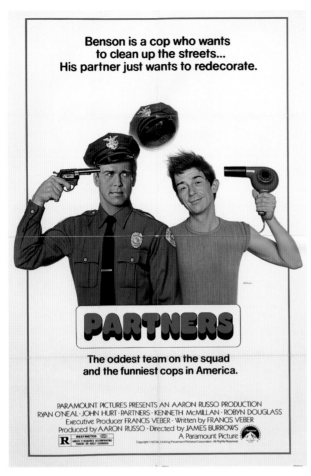

PARTNERS (1982)
PARAMOUNT PICTURES

As a reflection of Hollywood's sophistication level about gay issues in the early '80s, this poster really speaks for itself.

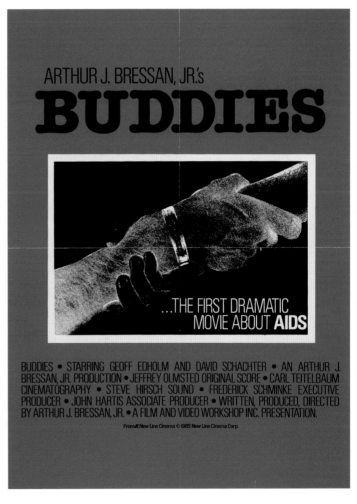

BUDDIES (1985)
NEW LINE CINEMA

Despite *Philadelphia's* attempts to claim the prize, Arthur Bressan's *Buddies* was the first narrative drama about AIDS. Ultra-low-budget and immensely powerful, *Buddies* tells the story of Robert (Geoff Edholm), who is dying of AIDS, and David (David Schachter), the gay man who starts visiting him as a volunteer counselor but becomes his greatest friend.

QUERELLE (1983)
GAUMONT

Rainer Werner Fassbinder's last film, based on the Jean Genet novel, stars Brad Davis as the *homme fatale* sailor Querelle. The U.S. campaign for *Querelle* settles for a simple hunky shot of Brad Davis leaning against a wall, with a lot of text about how this is "Fassbinder's last and most controversial film." The French have him leaning against something much more interesting.

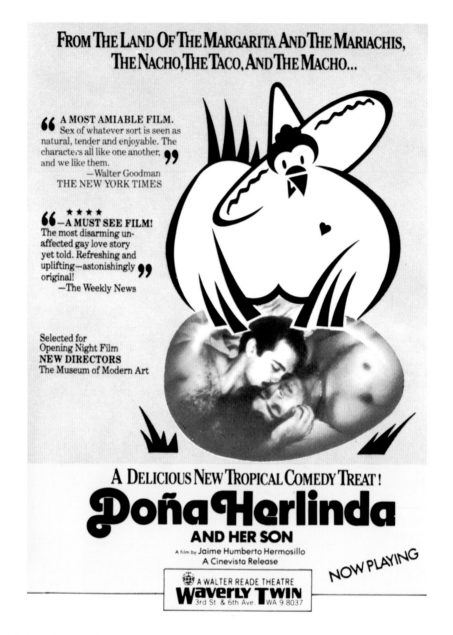

FROM THE LAND OF THE MARGARITA AND THE MARIACHIS, THE NACHO, THE TACO, AND THE MACHO...

" A MOST AMIABLE FILM. Sex of whatever sort is seen as natural, tender and enjoyable. The characters all like one another, and we like them. "
—Walter Goodman
THE NEW YORK TIMES

★ ★ ★ ★
" —A MUST SEE FILM! The most disarming un-affected gay love story yet told. Refreshing and uplifting—astonishingly original! "
—The Weekly News

Selected for
Opening Night Film
NEW DIRECTORS
The Museum of Modern Art

A DELICIOUS NEW TROPICAL COMEDY TREAT!
Doña Herlinda
AND HER SON
A film by Jaime Humberto Hermosillo
A Cinevista Release

NOW PLAYING

A WALTER READE THEATRE
Waverly Twin
3rd St. & 6th Ave. WA 9 8037

DONA HERLINDA AND HER SON
(DOÑA HERLINDA Y SU HIJO) (1986)
CINEVISTA

The unbelievably reductive U.S. ad tagline for this Mexican comedy ("From the land of the margarita and the mariachis, the nacho, the taco and the macho…") was apparently meant as a humorous appeal to the non-Hispanic art-house crowd, whose knowledge of Mexico was limited and primarily culinary. Not to mention the image of the mother hen in a sombrero, perched atop the egg-shaped photo of her gay son and his lover. The film itself is a gem. Marco Antonio Treviño stars as the macho Rodolfo, who is in love with Ramón (Arturo Meza). When Rodolfo's manipulative but loving mother (Guadalupe del Toro) insists he get married and make her a grandmother, she invites Ramón to come live with them as well ("Rodolfo has such a big bed," she deadpans). *Doña Herlinda and Her Son* opened in New York City the same week as *Parting Glances* (page 90), *My Beautiful Laundrette* (page 98), and *Desert Hearts* (page 95), prompting *Film Comment* to proclaim the arrival of the Gay New Wave.

THE TIMES OF HARVEY MILK (1985)
NEW YORKER FILMS

Rob Epstein won the 1985 Oscar for best documentary with this powerful account of the assassination of San Francisco's first openly gay elected official. The one-sheet's simple design eloquently conveys the film's tragic story by contrasting the buoyant image of city supervisor Harvey Milk with the text about his assassination.

HE WAS POWERFUL, CHARISMATIC, COMPASSIONATE AND GAY. AFTER ELEVEN MONTHS IN OFFICE HE WAS ASSASSINATED.

THE TIMES OF HARVEY MILK

A Film by **ROBERT EPSTEIN** and **RICHARD SCHMIECHEN**
Produced by **RICHARD SCHMIECHEN** • Directed and Co-Produced by **ROBERT EPSTEIN**
Edited by **DEBORAH HOFFMANN** and **ROBERT EPSTEIN** • Music by **MARK ISHAM**
Narrated by **HARVEY FIERSTEIN**

Cinecom
INTERNATIONAL FILMS

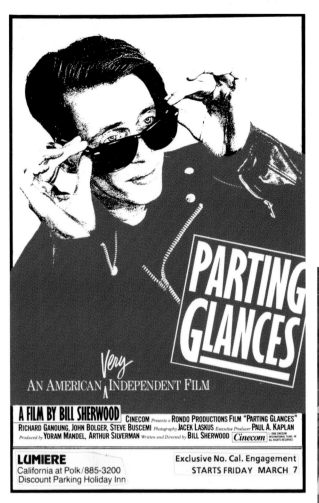

PARTING GLANCES (1986)

CINECOM INTERNATIONAL

Bill Sherwood's much-loved gay indie tells the story of Michael and Robert, a gay couple in New York City, and features a terrific performance by Steve Buscemi as Nick, Michael's gay best friend, who has AIDS.

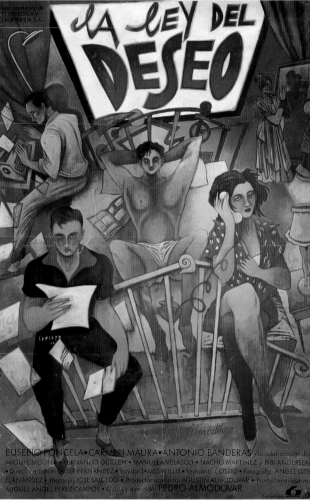

LAW OF DESIRE *(LA LEY DEL DESEO)* (1987)

EL DESEO S.A.

Pedro Almodóvar made his first big U.S. splash with this gay romantic comedy starring future Hollywood superstar Antonio Banderas and the lovely Carmen Maura (as his transsexual sister). The U.S. ad campaign (not shown) prominently features Banderas with his shirt off. This original Spanish poster is a bit more artistic.

FROM THE DIRECTOR OF 'MY BEAUTIFUL LAUNDERETTE'

PRICK UP YOUR EARS

"ONE OF THE MOST REMARKABLE
BRITISH FILMS OF THE DECADE"
Sunday Times

"FIRST-RATE"
Film '87

"SPLENDID"
Observer

"WICKEDLY FUNNY"
Today

A CIVILHAND ZENITH film

GARY OLDMAN ALFRED MOLINA
with VANESSA REDGRAVE as "Peggy"

PRICK UP YOUR EARS (18)

Photographed by	Music by	Based on the biography by	Screenplay by	Produced by	Directed by
OLIVER STAPLETON	**STANLEY MYERS**	**JOHN LAHR**	**ALAN BENNETT**	**ANDREW BROWN**	**STEPHEN FREARS**

The biography of Joe Orton by JOHN LAHR is available from Penguin Books. Released by Curzon Film Distributors. Distributed by Palace Pictures. Album available on SILVA SCREEN records and cassettes. DESIGNED & PRINTED BY DEWYNTERS LTD.

PRICK UP YOUR EARS (1987)
PALACE PICTURES

This evocative British quad for the Joe Orton biopic *Prick Up Your Ears* is done in the plain and simple style of a British film poster of the 1960s (the era in which the film is set). Beneath the deceptively simple design (from London's Dewynter, Ltd.) lies a clever visual trick no doubt lost on many audiences. Note the way the text is "pricking" upward.

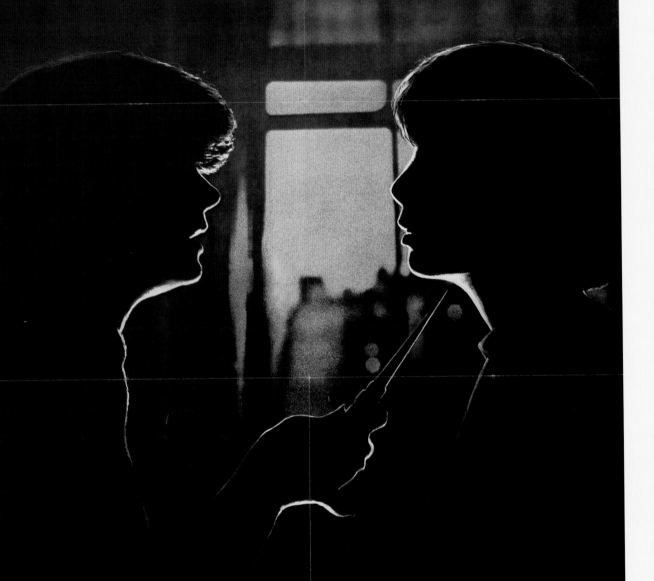

Somebody loves Emily... too much

WINDOWS

A MICHAEL LOBELL Production "WINDOWS"
TALIA SHIRE JOSEPH CORTESE and ELIZABETH ASHLEY as "Andrea"
Written by BARRY SIEGEL Directed by GORDON WILLIS
Produced by MICHAEL LOBELL Music composed by ENNIO MORRICONE

RESTRICTED
UNDER 17 REQUIRES ACCOMPANYING
PARENT OR ADULT GUARDIAN

United Artists
A Transamerica Company

PERSONAL BEST (1982)

GEFFEN PICTURES/WARNER BROTHERS

One line of text utilized in all the ad designs for this sporty lesbian drama conveys quite clearly the audience to which this movie is pitched. The line: "Featured in the April issue of *Playboy*." The audience: not lesbians, but straight men. The teaser poster (released before the film) takes a sensitive approach, conveying the theme of athletic competition among women (not exactly a guaranteed blockbuster at the box office). The subsequent style A one-sheet goes for the gold, with Mariel Hemingway in a wet T-shirt and a sexy tagline that makes clear what these two girls have been doing in bed together after practice. The lesbianism of Hemingway's character is treated as a phase (she goes off with a male water-polo player in the end), while Patrice Donnelly's character (who is at least portrayed as a "real" lesbian) gets to utter some really great lines, such as (in response to Hemingway's reluctance to define the true nature of their relationship): "We may be friends, but we also happen to fuck each other every once in a while." And (on meeting Hemingway's new boyfriend): "He's pretty cute... for a guy."

WINDOWS (1980)

UNITED ARTISTS

The same studio that brought us *Cruising* offers equal-opportunity offensiveness for lesbians as Elizabeth Ashley stalks Talia Shire in this awful lesbian psycho-killer thriller, directed by the otherwise talented cinematographer Gordon Willis.

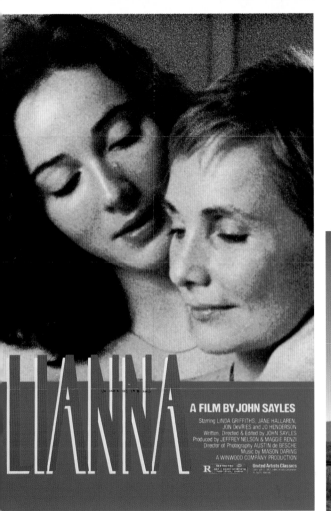

LIANNA (1983)
UNITED ARTISTS CLASSICS

The candid look of this shot captures a terrific sexy but soft intimacy, which reflects the feeling of the film as a whole—an earnest and well-meaning lesbian drama (though the downcast eyes are a bit too reminiscent of *The Children's Hour*; page 29). The U.S. one-sheet has no tagline, while the British quad (using the same photo) goes with this concise description: "A sensitive, tender and provocative love story." Rex Reed described the film as "100 times better than *Personal Best*. But... don't lesbians ever have any fun?"

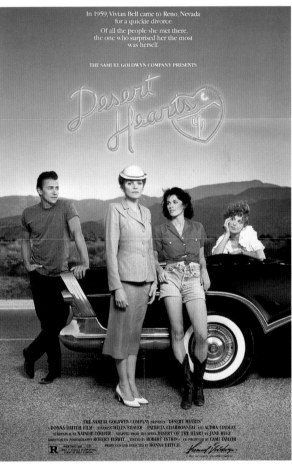

DESERT HEARTS (1986)
SAMUEL GOLDWYN COMPANY

Donna Deitch pioneered the genre of indie lesbian filmmaking with this film adaptation of the classic Jane Rule novel (a lesbian love story set in Reno in the 1950s). The U.S. one-sheet conveys the lesbian theme as we see wild and sexy Cay (Patricia Charbonneau) making eyes at prim and proper Vivian (Helen Shaver). But the design also incorporates a minor male character and a minor female character, both of whom are barely seen in the film (presumably in an effort to appeal to a broader audience who would not come out to see a mere lesbian romance). *Desert Hearts* still stands as the top-grossing lesbian-made lesbian feature of all time (drawing $2.4 million at the box office).

THE HUNGER (1983)
METRO-GOLDWYN-MAYER

Aging vampire Catherine Deneuve dumps David Bowie for Susan Sarandon. Wouldn't you? This one stands alongside *My Beautiful Laundrette* (page 98) as an outstanding example of a quintessentially '80s one-sheet design.

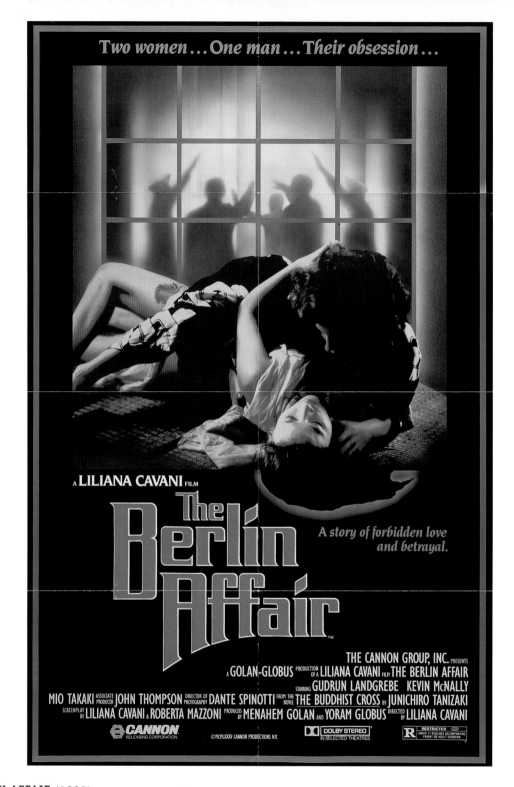

THE BERLIN AFFAIR (1985)
CANNON FILM DISTRIBUTORS

Mio Takaki stars as Mitsuko, the seductive young daughter of the Japanese ambassador, who falls into bed with Louise (Gudrun Landgrebe), the wife of a Nazi diplomat. This obscure World War II period drama has some nice lesbian romance until Louise's husband starts sleeping with Mitsuko and the film shifts into heavy melodrama mode. Directed by Liliana Cavani, this English-language German-Italian coproduction was not released theatrically in the United States until 1988.

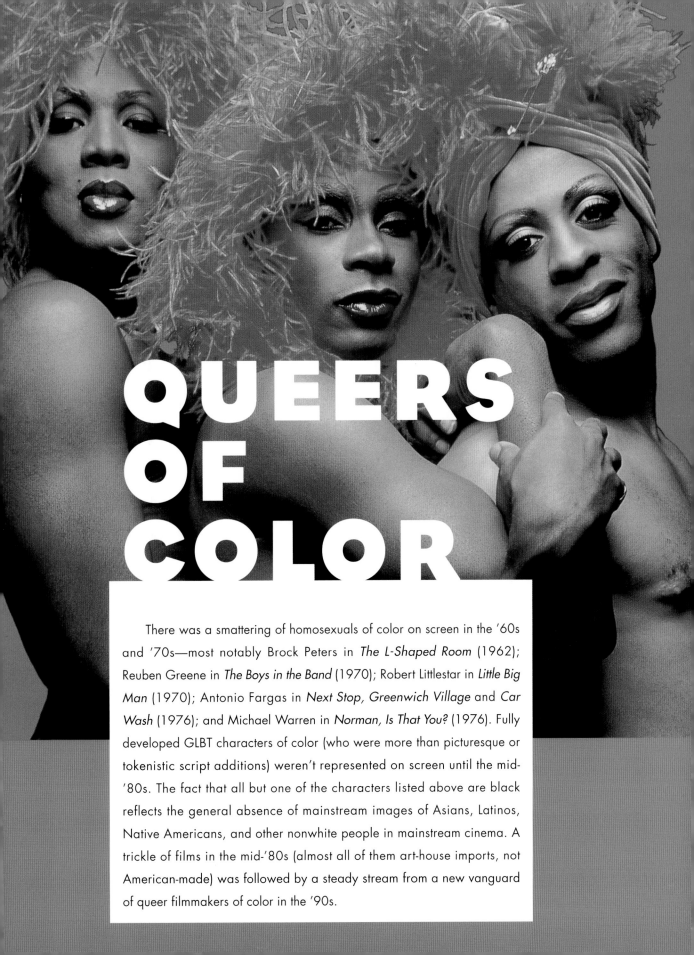

QUEERS OF COLOR

There was a smattering of homosexuals of color on screen in the '60s and '70s—most notably Brock Peters in *The L-Shaped Room* (1962); Reuben Greene in *The Boys in the Band* (1970); Robert Littlestar in *Little Big Man* (1970); Antonio Fargas in *Next Stop, Greenwich Village* and *Car Wash* (1976); and Michael Warren in *Norman, Is That You?* (1976). Fully developed GLBT characters of color (who were more than picturesque or tokenistic script additions) weren't represented on screen until the mid-'80s. The fact that all but one of the characters listed above are black reflects the general absence of mainstream images of Asians, Latinos, Native Americans, and other nonwhite people in mainstream cinema. A trickle of films in the mid-'80s (almost all of them art-house imports, not American-made) was followed by a steady stream from a new vanguard of queer filmmakers of color in the '90s.

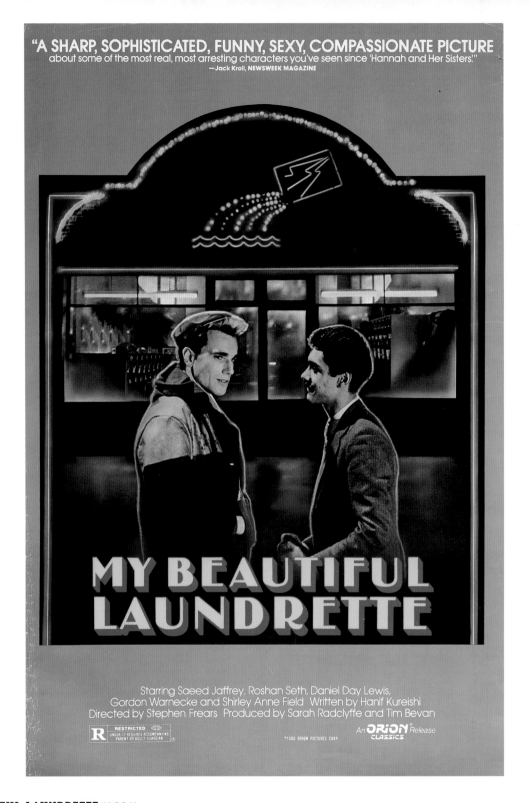

MY BEAUTIFUL LAUNDRETTE (1986)

ORION CLASSICS

Directed by Stephen Frears from a script by Hanif Kureishi, this groundbreaking feature offers the first fully realized gay interracial screen romance—between white punker Johnny (Daniel Day-Lewis) and Anglo-Pakistani laundry owner Omar (Gordon Warnecke). Although the one-sheet art betrays its mid-'80s origins, the film itself stands the test of time as it deals with racism and assimilation in Britain by way of a gay love story.

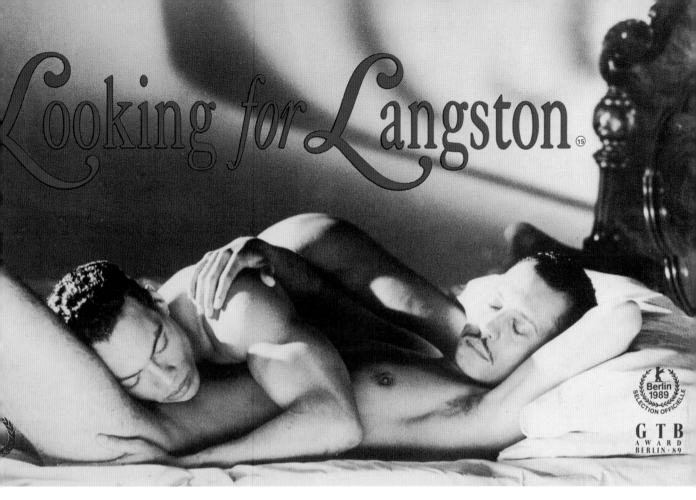

Looking for Langston ⑮

A SECRET AFFAIR · A MASQUERADE · A DANCE OF SEDUCTION...

SHE·MUST·BE SEEING·THINGS

A FILM BY SHEILA McLAUGHLIN

STARRING
SHEILA DABNEY · LOIS WEAVER WITH KYLE DeCAMP · JOHN ERDMAN

DIRECTOR OF PHOTOGRAPHY MUSIC BY EDITOR PRODUCER FOR Z.D.E.-TV
MARK DANIELS JOHN ZORN ILA VON HASPERG BRIGITTE KRAMER

"A Wryly Sophisticated Comedy"
– JAY CARR, BOSTON GLOBE

LOOKING FOR LANGSTON (1988)
BRITISH FILM INSTITUTE

Isaac Julien's gorgeous experimental meditation on Langston Hughes and the Harlem Renaissance broke new ground as it represented black gay desire on screen. This British quad conveys a sense of the film's eroticism and highly stylized black-and-white cinematography.

SHE MUST BE SEEING THINGS (1987)
FIRST RUN FEATURES

Sheila McLaughlin's low-budget lesbian drama stars Lois Weaver as Jo, a white lesbian filmmaker, and Sheila Dabney as Agatha, a Brazilian-born attorney. The two lovers grapple with Jo's bisexuality and Agatha's jealousy, as well as their burgeoning interest in S/M. *She Must Be Seeing Things* is notable as one of the first lesbian indies to spotlight an interracial relationship. Released by First Run Features on the heels of *Desert Hearts*, the film's humble production values are reflected in this simple poster.

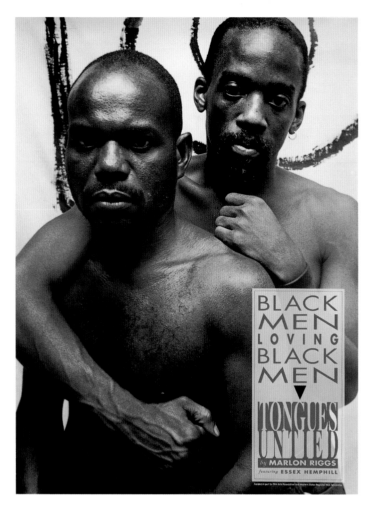

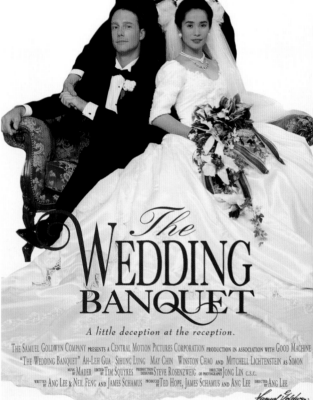

TONGUES UNTIED (1991)
SIGNIFYIN' WORKS/FRAMELINE DISTRIBUTION

This simple image of two black gay men (Marlon Riggs and Essex Hemphill) being boldly physically affectionate with each other reflects the underlying artistry of Riggs's powerful personal documentary on black gay identity. *Tongues Untied* won numerous film festival awards in 1990 before it was scheduled for national public-television broadcast in July 1991 (on the independent documentary series *P.O.V.*). That summer brought virulent attacks from the conservative right, which condemned the film as pornographic and attacked both PBS and the NEA for having funded it. While the *Atlanta Constitution* described *Tongues Untied* as "without a doubt the most explicit, profane program ever broadcast by a television network," Vito Russo, writing in *The Advocate*, celebrated the film as "a brilliant, innovative work of art that delivers a knock-out political punch." In many ways, Riggs later said, the national media attention surrounding the broadcast fulfilled his greater goal of challenging "society's most deeply entrenched myths about what it means to be black, gay, a man, and above all, human." Riggs, who died of AIDS in 1994, was a pioneer in the vibrant and innovative movement of queer film and videomakers of color, which burgeoned in the 1990s. *Tongues Untied* is an unparalleled example of personal, experimental documentary filmmaking and is as inspiring today as it was then.

THE WEDDING BANQUET (1993)
SAMUEL GOLDWYN COMPANY

Ang Lee's second feature as writer-director was this Taiwanese-U.S. coproduction about a Chinese American gay man, Wai-Tung (Winston Chao), who lives with his white lover, Simon (Mitchell Lichtenstein), in New York City. In order to placate his aging parents in Taiwan, Wai-Tung embarks on a marriage of convenience to a Chinese woman in need of a green card. Complications arise when the parents show up for the wedding. *The Wedding Banquet* became the top-grossing gay indie of its time, bringing in nearly $7 million at the box office.

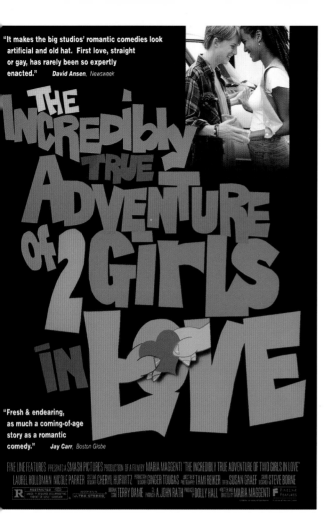

THE INCREDIBLY TRUE ADVENTURE OF TWO GIRLS IN LOVE (1995)
FINE LINE FEATURES

Writer-director Maria Maggenti pulls off a terrific teen lesbian story about the love between poor white tomboy Randy (Laurel Holloman) and her affluent African-American classmate Evie (Nicole Ari Parker). Randy services Evie's Range Rover at the gas station, and things get going from there. On the film's initial release, Roger Ebert commented, "The R rating is ironic when you reflect on how much healthier and more thoughtful this film is than so much mindless, action-oriented 'family entertainment.'"

STONEWALL (1995)
STRAND RELEASING

Though it's a bit of a soap-opera melodrama, this BBC production boldly spotlights the black and Latino drag queens at the center of the historic Stonewall Riots, and Duane Boutte as Bostonia and Guillermo Diaz as La Miranda give terrific performances. La Miranda's new masculine white boyfriend, Matty Dean (Fred Weller), serves as the figure with whom gay white male viewers can identify, and he is prominently featured in the poster encouraging those GWMs to buy tickets. The screenplay was adapted from the Martin Duberman book by Anglo-black writer Rikki Beadle Blair, who went on to create the BBC series *Metrosexuality*.

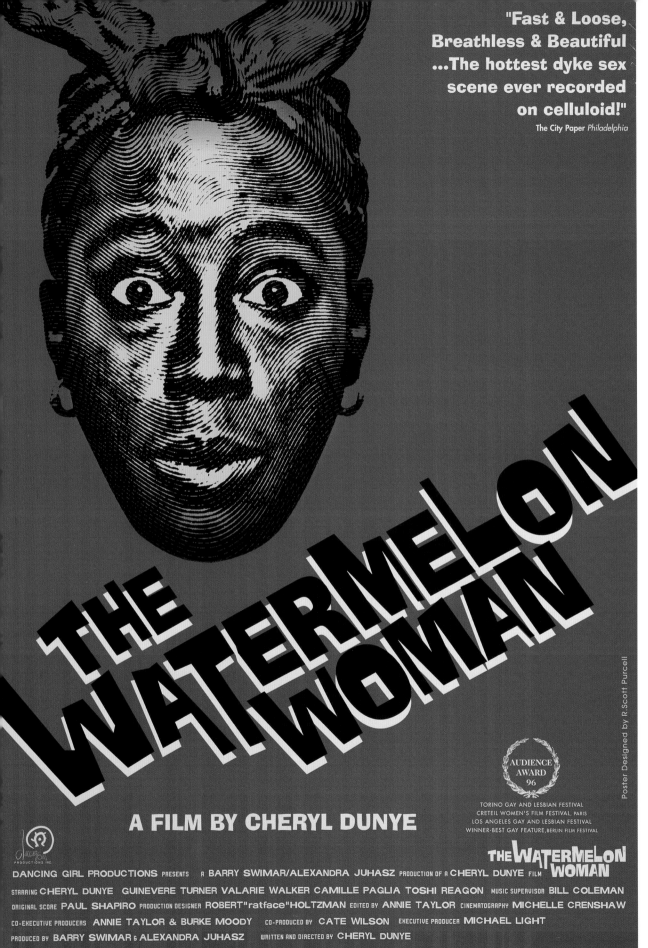

"Fast & Loose,
Breathless & Beautiful
...The hottest dyke sex
scene ever recorded
on celluloid!"
The City Paper *Philadelphia*

THE WATERMELON WOMAN

Poster Designed by R.Scott Purcell

AUDIENCE
AWARD
96

TORINO GAY AND LESBIAN FESTIVAL
CRETEIL WOMEN'S FILM FESTIVAL, PARIS
LOS ANGELES GAY AND LESBIAN FESTIVAL
WINNER-BEST GAY FEATURE, BERLIN FILM FESTIVAL

A FILM BY CHERYL DUNYE

THE WATERMELON
WOMAN

DANCING GIRL PRODUCTIONS PRESENTS A BARRY SWIMAR/ALEXANDRA JUHASZ PRODUCTION OF A CHERYL DUNYE FILM
STARRING CHERYL DUNYE GUINEVERE TURNER VALARIE WALKER CAMILLE PAGLIA TOSHI REAGON MUSIC SUPERVISOR BILL COLEMAN
ORIGINAL SCORE PAUL SHAPIRO PRODUCTION DESIGNER ROBERT "ratface" HOLTZMAN EDITED BY ANNIE TAYLOR CINEMATOGRAPHY MICHELLE CRENSHAW
CO-EXECUTIVE PRODUCERS ANNIE TAYLOR & BURKE MOODY CO-PRODUCED BY CATE WILSON EXECUTIVE PRODUCER MICHAEL LIGHT
PRODUCED BY BARRY SWIMAR & ALEXANDRA JUHASZ WRITTEN AND DIRECTED BY CHERYL DUNYE

A FIRST RUN FEATURES RELEASE

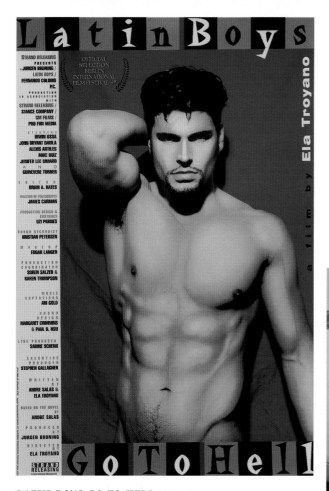

LATIN BOYS GO TO HELL (1997)
STRAND RELEASING

Indie distributor Strand Releasing pushes the naked-torso envelope out to its abdominal muscles in this poster for the gay *telenovela* sex comedy from Ela Troyano. The muscles belong to star Mike Ruiz.

THE WATERMELON WOMAN (1996)
FIRST RUN FEATURES

This wonderfully innovative debut feature from African American writer-director-actor Cheryl Dunye was the first, and remains the only, African American lesbian feature to be theatrically released in the United States. Dunye cast herself as a contemporary documentary filmmaker working on a profile of an African American 1930s Hollywood actress (known as the Watermelon Woman). Then she interweaves her faux-documentary sequences with a fictional narrative about lesbian life and love in contemporary Philadelphia. Like *Tongues Untied* (page 100), the film had the distinction of being debated in Congress when right-wing conservatives objected to the fact that it had received funding from the National Endowment for the Arts. The poster design, featuring Dunye in black mammy drag, is similar to the original design for the Godfrey Cambridge comedy *The Watermelon Man* (a story about a bigoted white man who wakes up black one morning!).

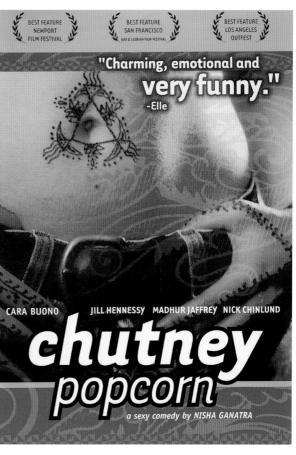

CHUTNEY POPCORN (2000)
MATA PRODUCTIONS

"A woman. Her girlfriend. A sister. Her husband. Their baby." This is the wacky tagline for writer-director Nisha Ganatra's clever New York City drama about an Indian American lesbian (Ganatra) who steps in to be a surrogate mother for her infertile sister and brother-in-law, much to the annoyance of her partner (Jill Hennessy). It's nice to see the lesbians getting in on the skin-showing marketing strategy in this poster for the New York City opening, and it's a very nice midriff indeed. The ultra-femme-sexy U.K. poster shows even more skin, is framed in multicolored daisies, and sports a fabulous glittering popcorn title treatment.

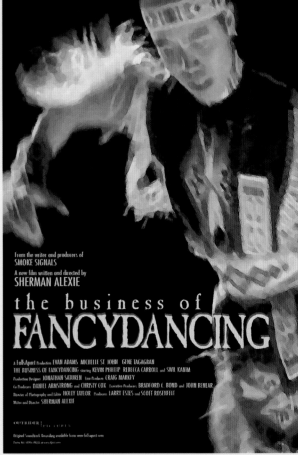

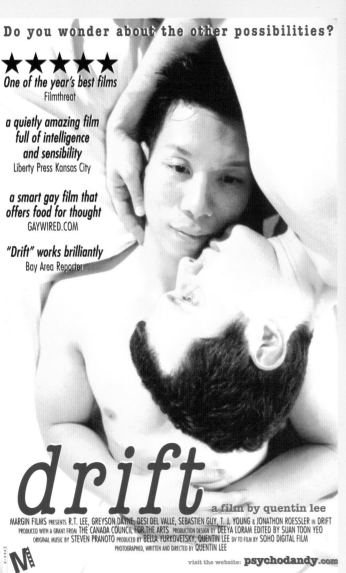

THE BUSINESS OF FANCYDANCING (2002)
FALLSAPART PRODUCTIONS/OUTRIDER PICTURES

Writer-director Sherman Alexie brought to the screen this story about Seymour (Evan Adams), a gay Native American writer who confronts his past when he returns to the reservation for the funeral of an old friend. *The Business of Fancydancing* was the first gay Native American drama to be theatrically released in the U.S.

DRIFT (2000)
MARGIN FILMS

This German-Canadian coproduction tells the story of Ryan (Reggie Lee), a Chinese Canadian gay man living in L.A. who begins having doubts about his three-year relationship with his white lover, Joel (Greyson Dayne), after he meets Leo (Jonathan Roessler) at a party. *Drift* envisions Ryan's various romantic possibilities à la Gwyneth Paltrow in *Sliding Doors*. The tenderly evocative one-sheet features Ryan wistfully pondering those "other possibilities" as Joel cradles him in his arms. The film was written, directed, and shot on digital video by Quentin Lee.

PUNKS (2000)
URBANWORLD FILMS

Theatrically released by Urbanworld, Patrik Ian-Polk's gay African American ensemble comedy did poorly at the box office despite positive reviews. The film's numerous campaigns include a series of six small posters, four of which are pictured here.

Punks

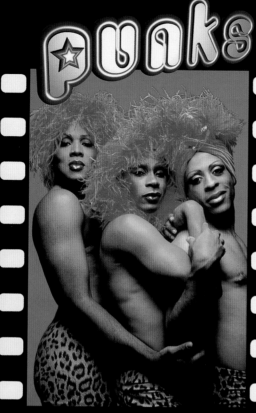

I'm just gon' reach in my bag,
snatch this ice pick out,
and we can set it off up in here

Punks

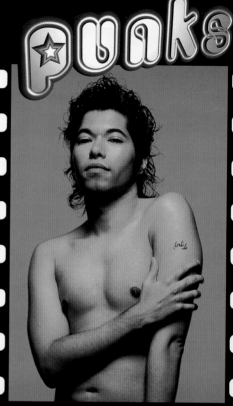

If upon meeting me,
a man is not instantly bowled over by my beauty
then he's clearly heterosexual.

Punks

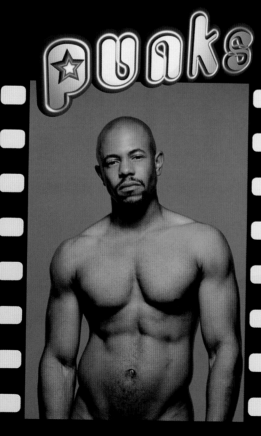

Who's your daddy?!

Punks

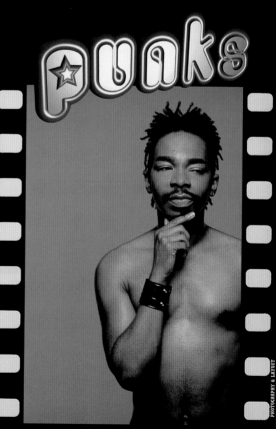

Bi-sexual men are like New York weather.
You never know which way to dress
when you get up in the morning.

CHAPTER V
THE '90s AND BEYOND

The '90s brought forth a new and exciting array of independent GLBT film productions. In 1991, B. Ruby Rich, writing in the *Village Voice*, pronounced the dawn of the New Queer Cinema, citing films like *Paris Is Burning* (1991), *The Living End* (1992), *Swoon* (1991), and *Poison* (1992). These and other groundbreaking queer films were often characterized by a corresponding honesty and directness in their marketing campaigns (the brilliant trailer for *Poison* features the first on-screen kiss between two men ever shown in a preview trailer). Recognizing the value of the "niche audience," studios such as New Line/Fine Line, Miramax, and the Samuel Goldwyn Company decided to create campaigns clearly designed to appeal to GLBT audiences, who were finally being noticed, if only for the depth of their pocketbooks. Meanwhile, smaller specialty distributors such as Strand Releasing, First Run Features, and Zeitgeist Films continued their commitment to bringing less-commercial GLBT movies to audiences everywhere.

The late '90s and early twenty-first century have also seen an exciting increase in the acceptance and embracing of GLBT themes and characters in mainstream popular entertainment. However, it is probably safe to say that truly representative, genuinely diverse, and politically progressive GLBT portrayals and marketing campaigns will continue to be the exception rather than the rule when it comes to large-scale Hollywood releases. As Vito Russo said some twenty years ago in *The Celluloid Closet*, "Don't expect *anything* from Hollywood."

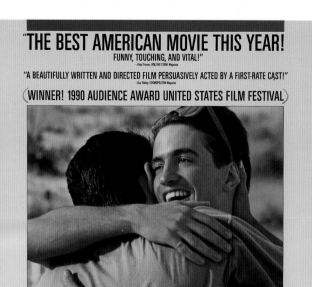

LONGTIME COMPANION (1991)

SAMUEL GOLDWYN COMPANY

Touted as "the first motion picture drama to focus on AIDS" (actually, Arthur Bressan's 1985 film *Buddies* was the first), *Longtime Companion* covers nine years in the lives of a group of gay men living in New York City, from the onset of the AIDS crisis in 1981 to the film's year of production, 1991. The film was widely praised, with *The Advocate* especially commenting that "it doesn't try to explain gay life to a mainstream audience." However, director Norman Rene makes this unfortunate comment in the film's press kit: "It was essential that the people we encounter are human and identifiable, so that the film is not about New Yorkers and gays, but about people with whom audiences could identify." (New Yorkers and gay people are not human and identifiable?) The warmth and affection of this terrific theatrical one-sheet were abandoned when it came time for the video-release poster, which features these same two men simply walking on an empty beach with their (minor-character) female friend, and the classic "really-it's-not-a-gay-film" tagline, "A motion picture for everyone."

NO SKIN OFF MY ASS (1991)

STRAND RELEASING

On the other end of the gay-cinema spectrum sits Canadian enfant te rible Bruce LaBruce, who first graced the big screen with his edgy imagir ings in 1991. The ultra-low-budget *No Skin Off My Ass* was the scrappies (and most sexually explicit) gay indie of the decade to see theatrice release in the United States (thanks to Strand Releasing). Strand's equall ultra-low-budget one-color one-sheets for the film were done as blueline (via the same printing process used for architectural blueprints). Man smaller distributors used this process in the '90s, as it was affordable an enabled them to do small print runs. Mostly the posters were used for wil posting in each city where the film opened. The ink on these bluelin posters fades easily, and for the most part these have not held up well ove the course of time. Limited to one color, the designs on these cheap posters tend to be pretty uninspiring—usually consisting of a single imag and a lot of text. Yet for *No Skin Off My Ass*, Strand worked within thes limitations to create a bold poster that perfectly reflects the aesthetic o the film.

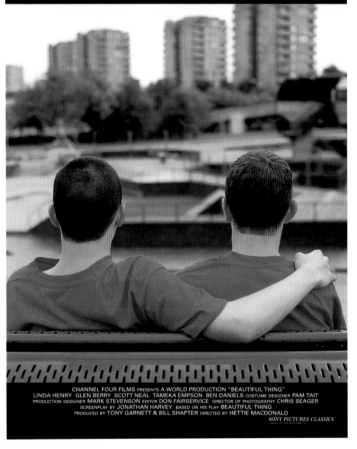

BEAUTIFUL THING

BEAUTIFUL THING (1996)

SONY CLASSICS

One of the best-loved gay movies of all time, *Beautiful Thing* tells the story of two British gay teens in love. This wonderfully understated U.S. one-sheet manages to convey the theme of gay young love in a way that is clever, poignant, and refreshing. An alternate U.S. one-sheet features an image of the two men embracing, with a half-screened version of the title text appearing as background.

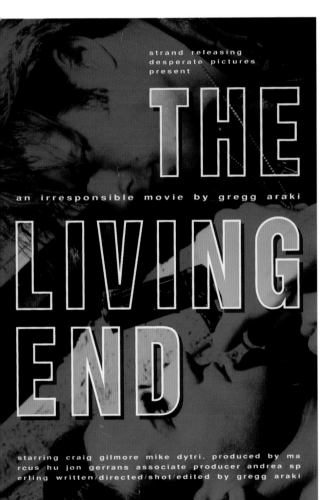

THE LIVING END (1992)

OCTOBER FILMS/STRAND RELEASING

Gregg Araki's "irresponsible movie" (a tale of two HIV-positive guys on a rampage) was part of the early-'90s vanguard of queer filmmakers who pushed the envelope of acceptable style and content for gay cinema. The bold one-sheet design conveys some of this edge, along with a sense of playful eroticism.

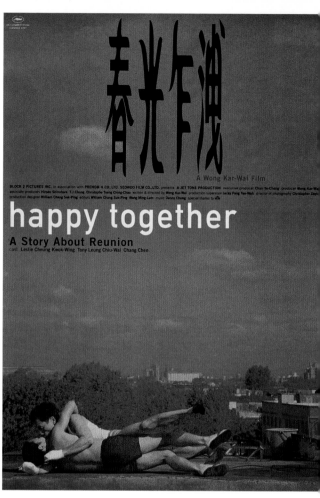

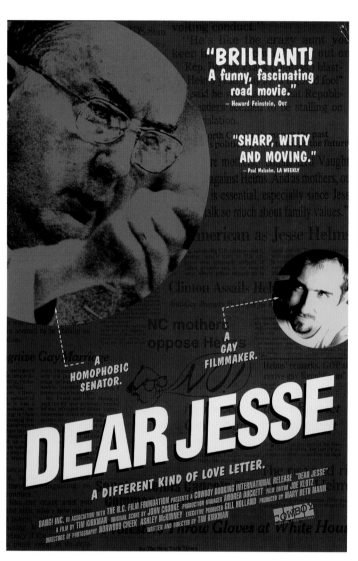

HAPPY TOGETHER (1997)
GOLDEN HARVEST COMPANY LTD.

Wong Kar-Wai's wonderfully agonizing gay romance stars Tony Leung and the late Leslie Cheung as gay lovers living in Argentina. The U.S. one-sheet (not pictured) evokes a tender intimacy: Leslie Cheung rests his head on Tony Leung's shoulder in the back seat of a taxi. The gorgeous Hong Kong poster, pictured here, shows us a much bolder image of gay love, as the two men wrestle passionately on a Buenos Aires rooftop.

DEAR JESSE (1997)
COWBOY BOOKING

Tim Kirkman's "love letter" to Senator Jesse Helms follows a long line of queer activist documentaries. This colorful theatrical one-sheet proves that you can be politically engaged and still have a sense of humor.

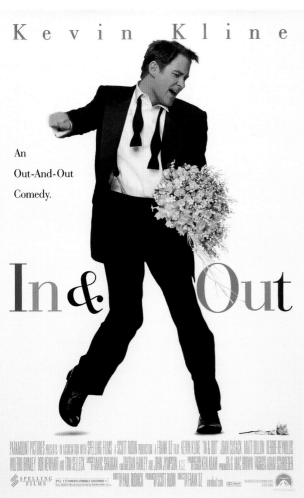

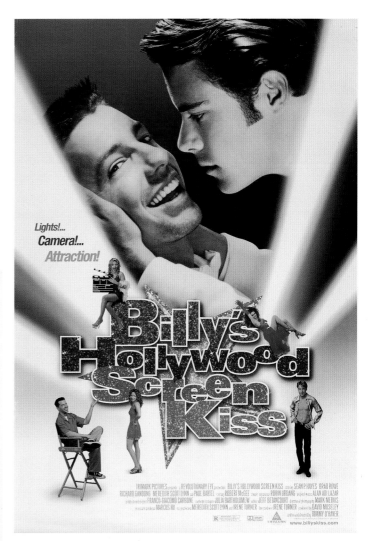

BILLY'S HOLLYWOOD SCREEN KISS (1998)
TRIMARK PICTURES

Before he became a megastar on *Will & Grace*, Sean Hayes first endeared himself to gay audiences with his portrayal of Billy, a gay photographer in L.A. who falls for a cute waiter (Brad Rowe), who is probably straight. For the U.S. theatrical one-sheet (pictured), Trimark Pictures gives us Sean on his back, about to be kissed; for the video-release poster (not shown), we get only the foreground images of Billy in the director's chair and so on.

IN & OUT (1997)
PARAMOUNT PICTURES

Bringing in $63 million at the box office, this mainstream comedy is based on Tom Hanks's inadvertent outing of his high school drama teacher (when he accepted the Best Actor Oscar for his role in *Philadelphia*). *In & Out* ranks as the third-highest-grossing gay-themed film ever at the U.S. box office (right behind *Philadelphia*, with $77 million, and *The Birdcage*, with $124 million).

what if you can't avoid
sexuality, guilt,
peer pressure,
lies, bigots, rumors,
misunderstanding,
parents, teachers,
nerds, jocks,
romance, loneliness,
shame and insecurity?
your only choice is to

get real.

school's out. so is steven carter.

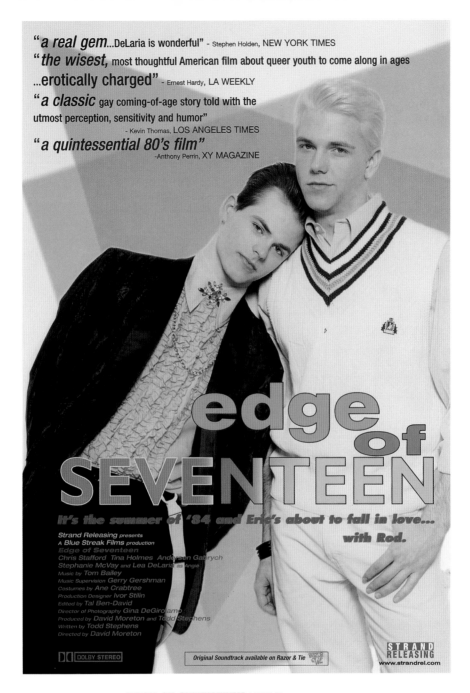

"*a real gem*...DeLaria is wonderful" - Stephen Holden, NEW YORK TIMES
"*the wisest,* most thoughtful American film about queer youth to come along in ages
...erotically charged" - Ernest Hardy, LA WEEKLY
"*a classic* gay coming-of-age story told with the
utmost perception, sensitivity and humor"
- Kevin Thomas, LOS ANGELES TIMES
"*a quintessential 80's film*"
-Anthony Perrin, XY MAGAZINE

edge
of
SEVENTEEN

It's the summer of '84 and Eric's about to fall in love...
with Rod.

Strand Releasing presents
A *Blue Streak Films* production
Edge of Seventeen
Chris Stafford Tina Holmes Andersen Gabrych
Stephanie McVay and Lea DeLaria as Angie
Music by Tom Bailey
Music Supervision Gerry Gershman
Costumes by Ane Crabtree
Production Designer Ivor Stilin
Edited by Tal Ben-David
Director of Photography Gina DeGirolamo
Produced by David Moreton and Todd Stephens
Written by Todd Stephens
Directed by David Moreton

DOLBY STEREO

Original Soundtrack available on Razor & Tie

STRAND
RELEASING
www.strandrel.com

EDGE OF SEVENTEEN (1998)
STRAND RELEASING

This charming indie period piece about a Midwestern high school kid coming out in the
'80s was a huge hit on the gay film festival circuit before its theatrical release—proving that
gay male audiences don't just want sexy movies with lots of nudity; they also want sweet,
romantic coming-out stories.

GET REAL (1998)
PARAMOUNT CLASSICS

This heartwarming teen coming-out tale from Britain had a wonderfully original market-
ing campaign that was used in both the U.K. and the U.S. The smartly worded run-on
text evokes the brilliant original U.K. *Trainspotting* campaign. The image of the colorful
shoes standing out from the crowd harks back to the *Torch Song Trilogy* bunny-slipper poster
(page 73).

BEFORE

A FILM BY JULIAN SCHNABEL

NIGHT

FALLS

JAVIER
BARDEM

OLIVIER
MARTINEZ

ANDREA
DI STEFANO

JOHNNY
DEPP

MICHAEL
WINCOTT

JON KILIK PRESENTS A GRANDVIEW PICTURES A FILM BY JULIAN SCHNABEL "BEFORE NIGHT FALLS"
JAVIER BARDEM·OLIVIER MARTINEZ·ANDREA DI STEFANO·JOHNNY DEPP·MICHAEL WINCOTT
CARTER BURWELL ADDITIONAL MUSIC BY LOU REED AND LAURIE ANDERSON EDITED BY MICHAEL BERENBAUM PRODUCTION DESIGNER SALVADOR PARRA
XAVIER PÉREZ GROBET·GUILLERMO ROSAS EXECUTIVE PRODUCERS JULIAN SCHNABEL·OLATZ LOPEZ GARMENDIA
CUNNINGHAM O'KEEFE·LAZARO GÓMEZ CARRILES·JULIAN SCHNABEL BASED ON THE MEMOIR BY REINALDO ARENAS
PRODUCED BY JON KILIK DIRECTED BY JULIAN SCHNABEL

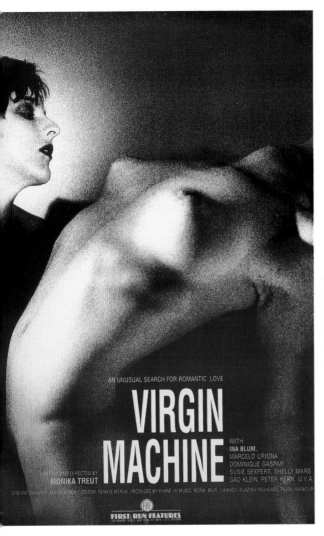

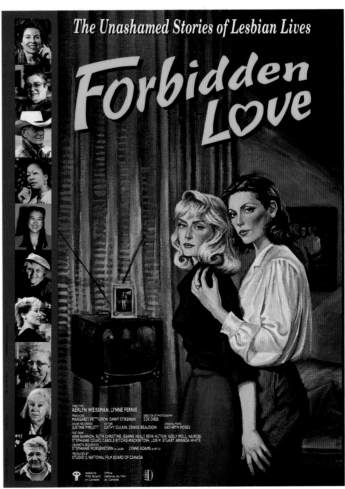

VIRGIN MACHINE
(DIE JUNGENFRAUENMASCHINE) (1988)
FIRST RUN FEATURES

Monika Treut's late-'80s German lesbian feature didn't hit American screens until 1991. The exceptionally stylized black-and-white image of star Dorothee Muller making love with a headless female torso makes this U.S. one-sheet stand out as touting a sexy lesbian film—most lesbian indie campaigns emphasize romance and relationships.

BEFORE NIGHT FALLS (2000)
FINE LINE FEATURES

Spanish actor Javier Bardem became an overnight gay heart-throb with his portrayal of exiled gay Cuban writer Reinaldo Arenas. Fine Line's bold poster design conveys the heroic strength and dignity of this gay protagonist. The style B version (not shown) has more queer emphasis, as it calls attention to Johnny Depp's performance and includes an inset picture of him in drag.

FORBIDDEN LOVE (1992)
NATIONAL FILM BOARD OF CANADA

The one-sheet for this terrific Canadian documentary about lesbian lives offers a fabulous lesbian pulp novel spoof. The film features interviews with a dozen older lesbian activists talking about what it was like to grow up queer in the '50s and '60s. The poster for *No Secret Anymore* (2003), JEB and Dee Mosbacher's documentary about Del Martin and Phyllis Lyon, also riffs on a pulp novel cover.

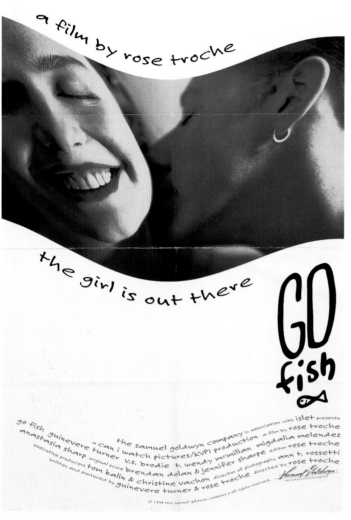

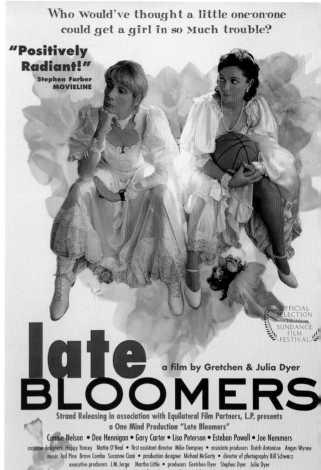

GO FISH (1994)
SAMUEL GOLDWYN COMPANY

Whoever would have thought it possible? The scruffy black-and-white dyke drama out of Chicago gets picked up at Sundance for worldwide release. While the U.S. theatrical one-sheet has a bit slicker look than the film itself, the design does convey the jubilant and poetically romantic spirit of this legendary lesbian feature. For the film's video release, Hallmark Entertainment utilized images from a new photo shoot featuring lead actress–writer Guinevere Turner in bed with a white sheet and a mysterious femmey girl (who is not in the film) getting out of bed in the background. The Samuel Goldwyn Company's original one-sheet design (which was nixed by Turner and director Rose Troche but was eventually used for the Israeli release of the film) features Turner's head superimposed on someone else's body. The only other person on the poster is a woman who appears briefly in the final scene of the movie (and who happens to be the straightest-looking girl in the film). The tagline reads: "Sex is important. So is friendship, romance, and laundry." A nice try, but nowhere near as classic as the film's eternally optimistic mantra: "The girl is out there."

LATE BLOOMERS (1995)
STRAND RELEASING

This comic riff about two middle-aged women who fall in love and want to get married has its heart in the right place but falls a bit flat in the execution—like an overly earnest *Afterschool Special*. The one-sheet is an eyecatcher, though, with its striking image of two brides and a basketball.

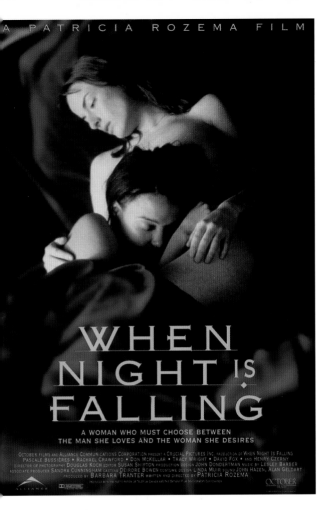

WHEN NIGHT IS FALLING (1995)

OCTOBER FILMS

Patricia Rozema's perennially popular Canadian lesbian drama took in more than $1 million at the U.S. box office. The stylized eroticism of the U.S. one-sheet certainly helped attract those ticket buyers (an initial NC-17 rating may have helped the draw as well). The poster for the German release (not shown) is wonderfully straightforward in its close-up depiction of a very hot kiss between the two protagonists.

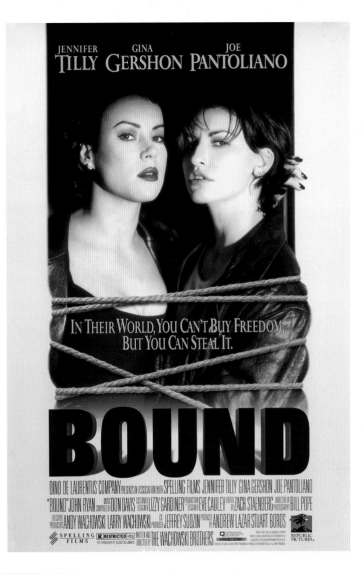

BOUND (1996)

GRAMERCY PICTURES

Considering it is a lesbian film made by a pair of straight guys, *Bound* made queer audiences pretty happy with its sexy and complex portrayal of the relationship between Corky (Gina Gershon) and Violet (Jennifer Tilly). It was also the top-grossing lesbian-themed feature of the '90s (it brought in $3.8 million domestically, nearly covering its $4.5 million budget). In this case, the video-release one-sheet (pictured) was designed to be more explicitly lesbian than the original theatrical one-sheet, which pictures the two women hanging U.S. currency on a clothesline and the not-very-interesting tagline, "Violet and Corky are making laundry day a very big day."

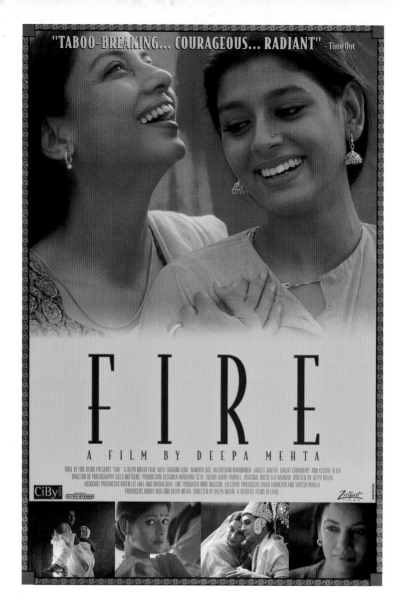

FIRE (1996)
ZEITGEIST FILMS

A Canadian-Indian coproduction, Deepa Mehta's *Fire* was critically acclaimed at film festivals worldwide. When it was released in India in 1998, this controversial lesbian drama was attacked by the fundamentalist Hindu group Shiv Shena. Protestors objecting to the lesbian storyline smashed windows and ransacked theaters in Bombay, Delhi, and other cities. This one-sheet is wonderfully upbeat in comparison with the film itself, which paints a pretty bleak picture of women's lives in India. Zeitgeist Films is renowned for its excellent poster designs, including such coveted pieces as the one-sheets for Todd Haynes's *Poison* (1991), Bruce Weber's *Chop Suey* (2001), and the German Golden Globe nominee *Aimee & Jaguar* (page 121).

HIGH ART (1997)
OCTOBER FILMS

This style B one-sheet gives us a delicious extreme close-up of Radha Mitchell being jumped by Ally Sheedy. In the nonlesbian style A version (sans Ally), the tousled and prone Radha is in a similar position on the bed but turns her head to gaze at the camera with a come-hither look. In both the *Bound* (page 117) and *High Art* one-sheets, the women look back at the viewer as though we have interrupted them mid-makeout session. Compare these bold, confident images to the posters for *Lianna* (page 95) and *The Children's Hour* (page 29).

ally sheedy radha mitchell

a story of ambition, sacrifice, seduction and other career moves.

a film by lisa cholodenko

high art

OCTOBER FILMS PRESENTS IN ASSOCIATION WITH 391 A DOLLY HALL PRODUCTION A LISA CHOLODENKO FILM "HIGH ART" ALLY SHEEDY RADHA MITCHELL GABRIEL MANN PATRICIA CLARKSON BILL SAGE ANH DUONG DAVID THORNTON and TAMMY GRIMES AS 'VERA' CASTING BY BILLY HOPKINS SUZANNE SMITH & KERRY BARDEN MUSIC BY SHUDDER TO THINK SUPERVISOR TRACY McKNIGHT DESIGNER VICTORIA FARRELL EDITOR AMY E. DUDDLESTON MUSIC BY BERNHARD BLYTHE PHOTOGRAPHY BY TAMI REIKER ASSOCIATE PRODUCER LORI E. SEID PRODUCERS DOLLY HALL JEFF LEVY-HINTE SUSAN A. STOVER WRITTEN AND DIRECTED BY LISA CHOLODENKO

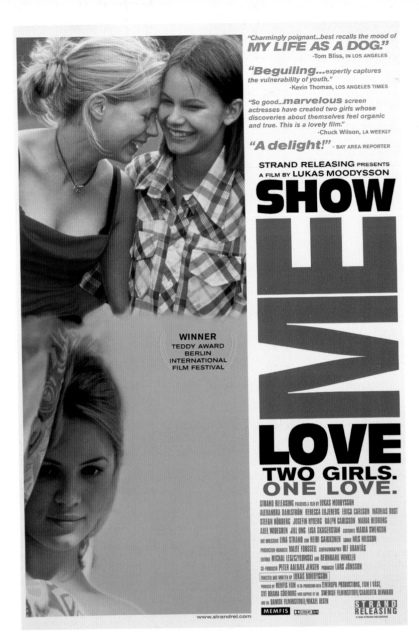

Within the poster:

"Charmingly poignant...best recalls the mood of
MY LIFE AS A DOG."
-Tom Bliss, IN LOS ANGELES

"**Beguiling**...expertly captures
the vulnerability of youth."
-Kevin Thomas, LOS ANGELES TIMES

"So good...**marvelous** screen
actresses have created two girls whose
discoveries about themselves feel organic
and true. This is a lovely film."
-Chuck Wilson, LA WEEKLY

"**A delight!**" - BAY AREA REPORTER

STRAND RELEASING PRESENTS
A FILM BY **LUKAS MOODYSSON**

SHOW ME

LOVE
TWO GIRLS.
ONE LOVE.

WINNER
TEDDY AWARD
BERLIN
INTERNATIONAL
FILM FESTIVAL

www.strandrel.com

SHOW ME LOVE *(FUCKING AMÄL)* (1998)
STRAND RELEASING

When it was first released in Sweden, this teen lesbian romance outgrossed *Titanic* to become the most successful Swedish film in history. It went on to win universal praise and scads of European film awards before tanking at the U.S. box office. The original title for the film is *Fucking Amäl* (Amäl is the small Swedish town where the film takes place).

AIMÉE & JAGUAR (1999)
ZEITGEIST FILMS

This schmaltzy World War II period piece is based on a true story about the love between a Jewish lesbian and the wife of a German officer. Costars Maria Schrader and Juliane Köhler shared the Best Actress prize at the Berlin Film Festival, and the film was nominated for a Golden Globe in the Best Foreign Language Film category. Both the U.S. and German posters utilize the same sexy but clichéd image of the women dancing; the original German tagline ("A love greater than death") was dropped on the U.S. release in favor of flattering pull quotes and awards credits.

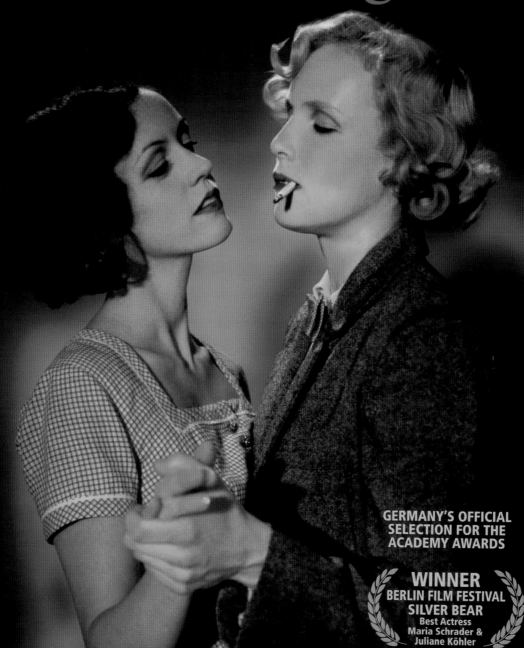

GOLDEN GLOBE NOMINEE BEST FOREIGN FILM

"KOHLER AND SCHRADER GIVE REMARKABLE PORTRAYALS
IN ROLES RICH IN DEPTH AND COMPLEXITY."
—The Los Angeles Times

"A POIGNANT, TRUE LOVE STORY SET IN WARTIME BERLIN."
—The New York Times

Aimée & Jaguar

GERMANY'S OFFICIAL
SELECTION FOR THE
ACADEMY AWARDS

WINNER
BERLIN FILM FESTIVAL
SILVER BEAR
Best Actress
Maria Schrader &
Juliane Köhler

HANNO HUTH presents a GÜNTER ROHRBACH / SENATOR FILM PRODUCTION
MARIA SCHRADER · JULIANE KÖHLER in AIMÉE & JAGUAR a MAX FÄRBERBÖCK film
HEIKE MAKATSCH · JOHANNA WOKALEK · ELISABETH DEGEN · DETLEV BUCK · INGE KELLER · KYRA MLADEK · DANI LEVY · DESIRÉE NICK · RÜDIGER HACKER
ULRICH MATTHES and PETER WECK Written by MAX FÄRBERBÖCK and RONA MUNRO based on a book by ERICA FISCHER · Composer JAN A. P. KACZMAREK
Set Design ALBRECHT KONRAD · Costume Design BARBARA BAUM · Editor BARBARA HENNINGS BFS · Director of Photography TONY IMI BSC · Casting RISA KES
Line Producer STEFAAN SCHIEDER · Associate Producer EBERHARD VON HALEM · Producers GÜNTER ROHRBACH · HANNO HUTH · Directed by MAX FÄRBERBÖCK
AMBERLON PICTURES WORLD SALES · A SENATOR FILM PRODUCTION · A ZEITGEIST FILMS RELEASE

SENATOR FILM

AMBERLON

article27.com

Zeitgeist

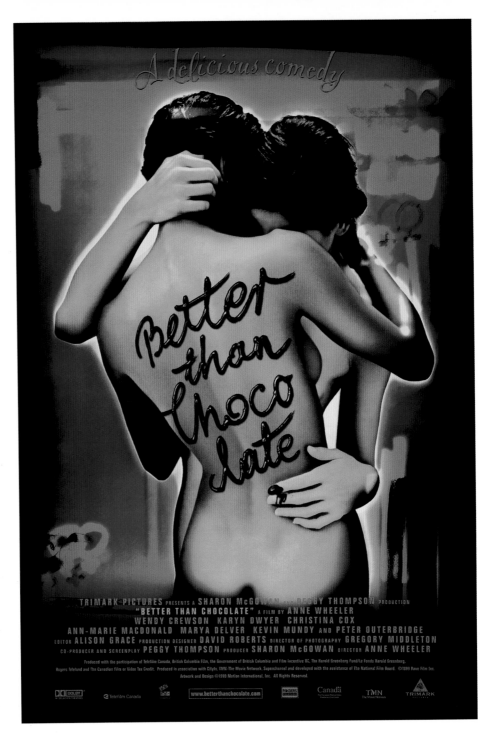

BETTER THAN CHOCOLATE (1999)

TRIMARK PICTURES

When Trimark released this Canadian lesbian romantic comedy in U.S. theaters, the *San Diego Union* newspaper refused to run the ads for the film. It wasn't the overtly sexy design they objected to, but the use of the word *lesbian* in a film critic's quote that was part of the ad. After Trimark complained that the newspaper had run an ad for the film *Trick* (1999) that included the word *gay*, the newspaper's national advertising director, Dexter LaPierre, replied, "We shouldn't be running that ad either." When *Better Than Chocolate* was released in Hong Kong, the poster was banned by censors, who claimed it was "offensive to public morality, decency, and ordinary good taste."

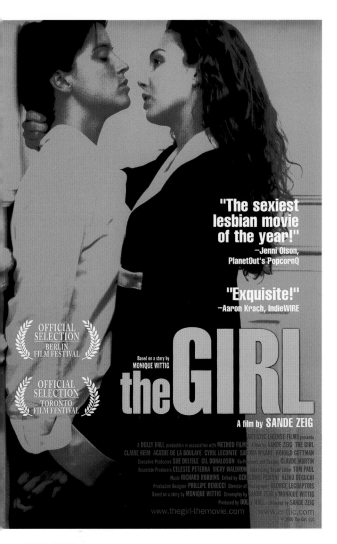

THE GIRL (2000)
ARTISTIC LICENSE FILMS

The sexy one-sheet for Sande Zeig's lesbian noir spotlights the film's two hot stars mid-seduction. *The Girl* was mostly panned by the critics, though almost everyone agreed that the sex scenes were not to be missed.

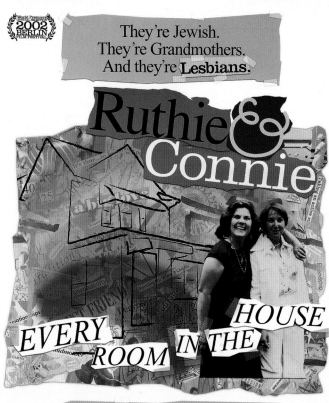

RUTHIE & CONNIE:
EVERY ROOM IN THE HOUSE (2002)
DONALD GOLDMACHER PRODUCTIONS

The faux-scrapbook design of the one-sheet conveys the home-made feeling of this uplifting documentary about a passionate and inspiring Jewish lesbian couple, Ruthie Berman and Connie Kurtz. *Ruthie & Connie* took home awards at numerous gay film festivals; this is the kind of film you want your parents to see. The poster design is by Rosenfeld and Bloom.

GUYS WITH THEIR SHIRTS OFF

The guy-with-his-shirt-off marketing strategy is a crucial factor in the box-office success of many queer films. See below for examples, and see also the posters for *Tongues Untied* (page 100), *Looking for Langston* (page 99), *Latin Boys Go to Hell* (page 103), *Punks* (page 105), and *Drift* (page 104). A related subset is the guys-in-their-undies genre—next time you're at the video store, keep an eye out for *All the Rage* (1998), *Amazing Grace* (1992), *Boys Shorts* (1993), and *Love Is the Devil* (1998), among others.

SEX IS... (1993)
OUTSIDER PRODUCTIONS

Marc Huestis and Lawrence Helman's wonderfully entertaining documentary took a pioneering approach when it asked ordinary gay men to talk about their sex lives. It also pioneered the straightforward guy-with-his-shirt-off approach to gay movie marketing. The one-sheet design is by Silvano Nova, the photo by Dan Nicoletta.

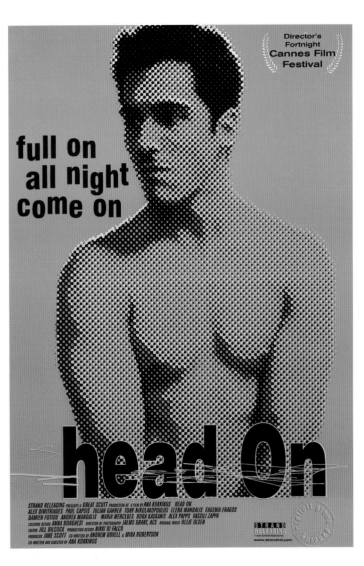

HEAD ON (1998)
STRAND RELEASING

This drama, about a day in the life of a Greek Australian gay man, features scads of drugs and sex and full-frontal nudity. The coarsely screened photo of the guy with his shirt off and the bright-orange background give this one-sheet a pop art feel that makes it stand out from the pack.

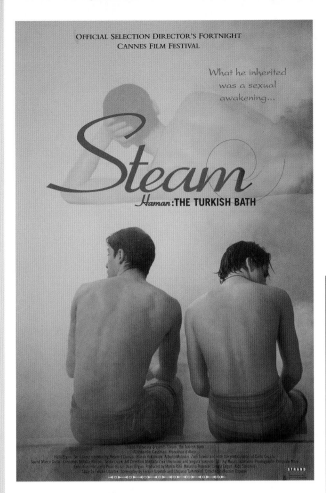

STEAM: THE TURKISH BATH *(HAMAM)* (1998)
STRAND RELEASING

This Turkish-Italian-Spanish coproduction focuses on the sexual awakening of a married man who inherits a *hamam* in Istanbul. As for the poster design: What could be better than a guy with his shirt off? Two guys with even more than their shirts off!

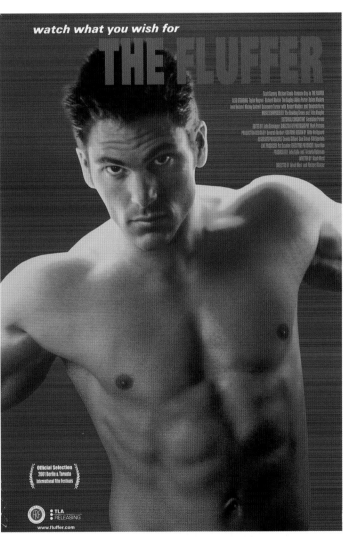

THE FLUFFER (2000)
FIRST RUN FEATURES/TLA RELEASING

Hunky poster boy Scott Gurney plays porn star Mikey (a.k.a. Johnny Rebel) in this behind-the-scenes drama about the gay porn industry. This U.S. theatrical one-sheet is a stellar example of the guy-with-his-shirt-off genre of gay movie marketing.

BEEFCAKE (1999)
ALLIANCE INDEPENDENT FILMS/STRAND RELEASING

Strand's U.S. one-sheet (not shown) utilizes a vintage full-body beefcake shot (of a guy with his shirt off, of course) to promote this docudrama about the physique films of the 1950s, which were the precursors to today's gay porn. Four different vintage beefcake shots were used for this set of small posters, which were also released as a set of promotional postcards. Canada's Alliance Independent Films also created *Beefcake* matchbook-size notepads and striptease ballpoint pens as promotional items. The film was directed by Thom Fitzgerald *(The Hanging Garden, The Event)*.

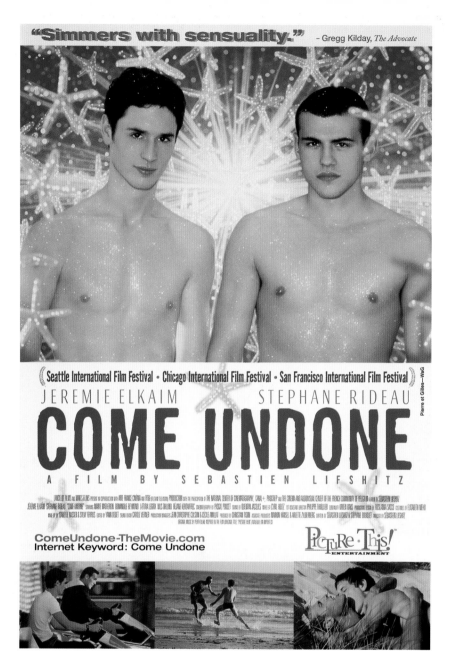

"Simmers with sensuality." — Gregg Kilday, *The Advocate*

Seattle International Film Festival · Chicago International Film Festival · San Francisco International Film Festival

JEREMIE ELKAIM STEPHANE RIDEAU

COME UNDONE

A FILM BY SEBASTIEN LIFSHITZ

ComeUndone-TheMovie.com
Internet Keyword: Come Undone

PicTuRe·This! ENTERTAINMENT

COME UNDONE *(PRESQUE RIEN)* (2000)
PICTURE THIS ENTERTAINMENT

Homoerotic cult icons Pierre et Gilles provided the promo image of the two guys with
their shirts off for this French gay summer romance.

101 RENT BOYS (2000)
WORLD OF WONDER/STRAND RELEASING

Fenton Bailey and Randy Barbato's World of Wonder production company has explored
everything from murderous club kids in New York City (see either the documentary or the nar-
rative feature version of *Party Monster*) to Monica Lewinsky *(Monica in Black and White)*. A
prolific portrait gallery of gay hustlers on Santa Monica Boulevard, *101 Rent Boys* is the kind
of gritty social documentary with a twist at which these guys excel. There is also, in fact, a full-
frontal version of David Littleton's fabulous poster design (featuring 101 penises), but we prefer
this one, of the guy with his undies off.

*101*Rent Boys

a film by randy barbato and fenton bailey

WORLD OF WONDER PRODUCTIONS, INC. IN ASSOCIATION WITH **CHANNEL FOUR** & **CINEMAX** PRESENTS "101 RENT BOYS"
PRODUCED AND DIRECTED BY **FENTON BAILEY** AND **RANDY BARBATO** EDITED BY **WILLIAM GRAYBURN**
ASSOCIATE PRODUCER **THAIRIN SMOTHERS** DIRECTOR OF PHOTOGRAPY **SANDRA CHANDLER** CASTING CONSULTANT **RICK CASTRO**
MUSIC BY **JIMMY HARRY** POST-PRODUCTION SUPERVISOR **EDUARDO MAGA—A** EXECUTIVE IN CHARGE OF PRODUCTION **HARRY KNAPP**
POSTER AND TITLE DESIGN BY **DAVID LITTLETON**

www.101rentboys.com

THE END

And with that, I'll say THE END and conclude with some optimistic predictions about the future of gay film and gay movie marketing. We will see more gay movies with campaigns that are genuinely mature and not sophomoric (I'll predict plenty of status-quo crap as well; it is *still* Hollywood, after all). The gay boys will be happy to see (but will eventually tire of) more skin and sex in indie gay film marketing than ever before, whether the films themselves are sexy or not. We lesbians will continue to get a steady stream of so-so features with really cute girls on the posters, and the occasional brilliant masterpiece that makes us hold out hope for the future. As transgender cinema evolves, we will see movies that really do change the ways all of us think about gender, along with posters that show respect and dignity for transgender lives. By the time my children are grown, they will look at this book and find today's cutting-edge representations of queer life completely hilarious and outdated compared to the movies of their own era, which will envision and reflect a societal reality for GLBT people that today exists only in our dreams.

INDEX

INDEX